SIGN PAINTERS

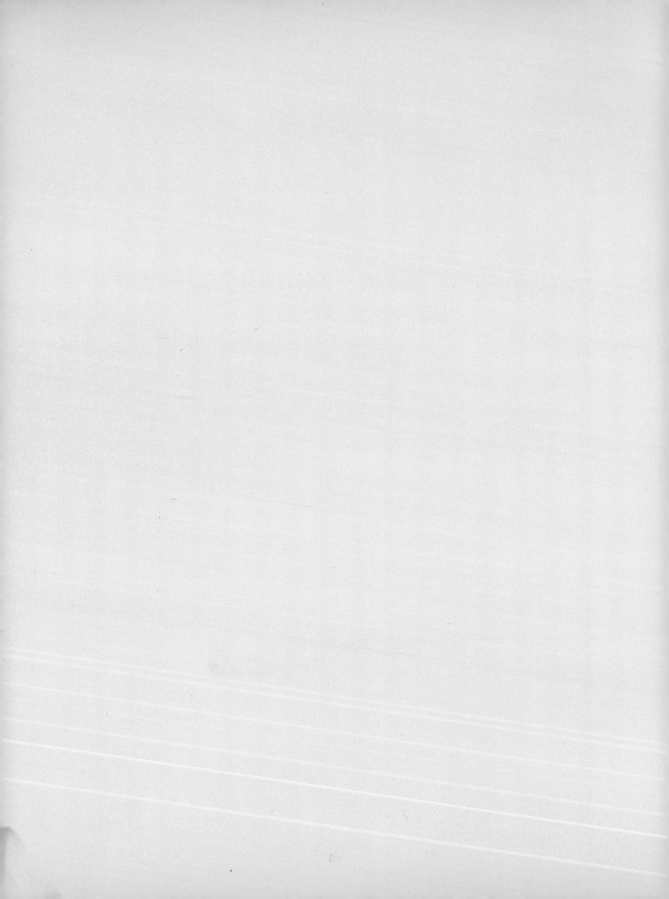

Sign Painters

FAYTHE LEVINE

and

SAM MACON

Foreword by

ED RUSCHA

PRINCETON ARCHITECTURAL PRESS · NEW YORK

Published by
Princeton Architectural Press
37 East 7th Street
New York, New York 10003

Visit our website at www.papress.com

Hand-painted front cover artwork: Ira Coyne
Hand-lettered interior typography: Josh Luke

Editor: Sara Bader
Book design: Paul Wagner
Design assistance: Benjamin English

Special thanks to: Bree Anne Apperley, Nicola Bednarek Brower,
Janet Behning, Fannie Bushin, Megan Carey, Carina Cha, Andrea Chlad,
Russell Fernandez, Will Foster, Jan Haux, Diane Levinson, Jennifer Lippert,
Jacob Moore, Gina Morrow, Katharine Myers, Margaret Rogalski, Elana Schlenker,
Dan Simon, Andrew Stepanian, and Joseph Weston of Princeton Architectural Press
—Kevin C. Lippert, publisher

Library of Congress
Cataloging-in-Publication Data
Levine, Faythe, 1977-
Sign painters / Faythe Levine and Sam Macon.
 p. cm.
ISBN 978-1-61689-083-4 (pbk. : alk. paper)
1. Signs and signboards—United States. I. Macon, Sam. II. Title.
HF5841 .L482012
659.13'42—DC23 2012012992

THIS BOOK IS DEDICATED
TO THE MEMORY OF
KEITH KNECHT (1940—2011),
WHOSE LOVE FOR THE
SIGN INDUSTRY WAS
APPARENT IN EVERYTHING
HE SHARED WITH US.

Table of Contents

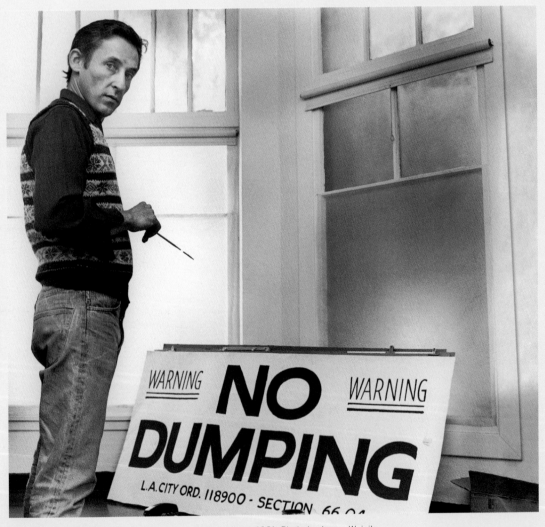

Ed Ruscha at 1024¾ North Western Avenue, Hollywood, ca. 1981. Photo by James Wojcik.

Foreword

ED RUSCHA

Growing up in the Southwest in the 1950s, I was exposed every day to hand-lettered signs, usually on wrinkly sheets of metal, say, for an unplanned watermelon sign or a hamburger menu. Some sign painters had the facility to make any word grouping look good and make any letter of the alphabet look stylish. The watermelon sign, a particular American icon, often misspelled and full of genuinely folkish paint strokes, was everywhere. Then there were the painters who added impressive illustrations along with the smoothly handled letterforms. Sometimes they did it with gloss black one-stroked enamel letters on a glossy white background. Wow! And the ecstasy of seeing a sign on metal with a beautifully built-up edge of paint bulging from one side of the letter stroke! It's not science, but it's beautiful and all artists recognize this. These painters knew about optical illusions, that some letters like *O* and *S* need to go a shade higher and lower than the baselines to appear equal in the lineup. This is something you take to heart.

I'm reminded of the late Clark Byers (ca. 1915–2004), known as the "barnyard Rembrandt." He painted SEE ROCK CITY (a roadside attraction outside of Chattanooga) on the sides of more than nine hundred barns in Tennessee and Georgia. He said, "I never passed up a good roof." That leads me to flash forward to today's world with our seven-story wrap-around motion graphics à la Las Vegas or Times Square.

The creators of hand-painted signs have engaged in an elegant and noble art form in all of its extremes, but in a world of computer plastics, where do we go? Children are not even taught longhand writing these days. You might say the closest thing to a sign painter would be a graffiti artist out on the street, looking for walls. (And boy, can they embellish Old English letters upside down and backward!)

We have seen sign painting grow from primitive instincts and humble beginnings to this present world of advanced culture. Obviously I am all for the triumph and nobility of the hand-painted item, but all sign makers, whatever their method, know you have to do one main thing:

P L A N A HEAD.

Ed Ruscha
Los Angeles, California, 2012

Preface

FAYTHE LEVINE & SAM MACON

FAYTHE: It's just a sign until it influences your entire life. My love for urban landscapes and signage predates my awareness of sign painters. I've always had a love for letters, and as I evolved as an artist in my early twenties my handwriting became an integral part of my artistic process. It was while I was living in Minneapolis in the late 1990s that sign painters entered my story.

My group of friends spent time hanging out on the West Bank at a café called Hard Times. It was there that I first saw and took note of signs painted by a guy we called "Sign Painter Phil." Phil Vandervaart ended up influencing and mentoring this group of friends, all of whom I've maintained a friendship with over the years. Ira Coyne, Japhy Witte, Sean Barton, Sven Lynch, and Forrest Wozniak stuck with brush lettering and work as traditional sign painters around America (except Sven, who now runs his shop in Stockholm, Sweden).

Phil's influence, first on my friends, and then trickling down to me, made a lasting impression. His work triggered an awareness, and I've never looked at signs the same way since. After wrapping up my last documentary and book, *Handmade Nation*, I kept thinking about the fact that there wasn't more information available on sign painters. It was surprising to me, considering the general interest most people have for the topic. It was then that I approached Sam, with whom I've

collaborated professionally over the years, to see if he wanted to codirect a documentary on sign painters. I was confident that his extensive experience as a director, and our mutual interest in design and typography, would benefit the project.

SAM: When Faythe approached me with the idea of making a documentary about sign painters I was intrigued, but I'd be lying if I said I knew what we were getting into. I've always been a visually minded person. Many of my earliest memories involve travel, much of which was by car. I'd stare out the window of the family station wagon and watch America transition from one place to the next. Even before I could read them, regionally specific signage denoted by color, shape, and design would indicate this passage. When we'd drive by an old painted barn sign demanding us to SEE ROCK CITY, I knew we were roughly halfway between Wisconsin and Florida. This basic awareness of signs grew and developed over the years, but it was not until we began this project that I learned what it was about good signs that draws me in.

FAYTHE AND SAM: So what makes a sign good? When we began this project we thought we knew. How wrong we were. We've learned that a great sign—a "perfect" sign, some would say—can be so simple that an average person wouldn't notice anything special about it, beyond the fact that it's telling you, "If you park here, you'll get towed." It's the expert sign painter's proficiency, talent, and ability that make a sign communicate effectively and keep you from the misery of the tow lot.

This book, like the job of the sign painter, isn't always about eye-popping, flashy designs. It's about process. It's about communication. It's about the experiences, years of practice, tricks of the trade, and design fundamentals learned over time that transform a person who just wants to paint signs into a great sign painter.

When we began this project people would always ask, "What's a sign painter?" Without knowing the half of it,

we'd attempt to answer this seemingly simple question.
The process has been enlightening, and we've learned a lot.
Although we now may be more qualified to answer that
question than we once were, these pages do a better job than
we ever could. The following stories, ruminations, images,
and thoughts, all from working sign painters, were collected
over almost two years of filming. These incredibly talented
individuals run the gamut in terms of age, focus, and experi-
ence; but whether they've been working for ten years or forty,
we feel their varied stories provide a solid foundation to learn
about what goes on behind the scenes. For the sign painters
out there, we hope the contents of this book ring true and read
like friendly shoptalk.

Our main goal with this book and film is to help show
the general public how sign painters contribute to our society.
Collecting these stories has been a humbling experience.
It's time to give the sign painters the recognition they deserve.
It's time to acknowledge their influence on our public space
and consciousness.

Faythe Levine & Sam Macon

Sign painter Chancey Curtis working in an unidentified theater, Mankato, MN, ca. 1930s.

Introduction

GLENN ADAMSON

I went to graduate school at Yale University, in New Haven, Connecticut. It is a city famously divided between town and gown, and also between black and white. Back in the 1960s there had been race riots, and a disastrous replanning of the city that ripped the heart out of downtown residential neighborhoods, replacing them with parking megastructures and highway overpasses raised on massive concrete piers. By the '90s, when I was there, things had improved a bit, but New Haven was effectively still a segregated city. Many people in the black community lived along a four-lane road called Dixwell Avenue, which angled up from the corner of campus to the northeast. Driving or walking along it was a memorable experience. It was a poor neighborhood, to be sure, with plenty of boarded-up buildings and empty lots, but there were also churches, Laundromats, nail salons, busy auto fix-it shops, and some of the best restaurants I've ever eaten in. (Sea Food Soul Food Express, how I miss you.) What struck me most about all of these establishments was their signs: hand painted in rounded italics, mostly blue and black letters with shadowing executed in a hard red. They spoke of businesses that were run by real people, businesses more or less free of corporate optimization. Were they all happy places to work? I don't know. But what I can say is that the signs themselves were joyful, expressive, and utterly unique.

And here's a crucial detail: almost all of them seemed to have been painted by a single hand. I didn't have the imagination back then to seek out the author of all this work. But there was clearly enough demand to sustain a professional career of some length, to judge from the number of signs and their varying ages, some brand-new and gleaming, some weathered and yellowed. Taken en masse, the hand lettering of this one person brought a unity to the Dixwell neighborhood, a sense of specific, place-based identity that digitally printed or vinyl-cut texts could never have provided. Just as a handwritten letter contains more of its writer's personality than an email, the crafting of these signs imbued New Haven's urban landscape with a degree of humanity, which would seem to be the one commodity that is easiest to come by but, in practice, is awfully difficult to find.

The anonymous "Master of Dixwell" (as I like to call him—or, who knows, maybe her?) was of course not unique. Many other cities, other neighborhoods, have had such public scribes. Some stick to the basics: letters on a blank white or yellow background, so the words jump out as you pass by at thirty-five miles an hour. Other painters enliven their work with images, or decorative motifs, or maybe make the sign itself into a sculptural object.

Fortunately Faythe Levine and Sam Macon have been finding these skilled practitioners and recording their methods, their stories, and their art. Levine could not be better suited to the task. Her first major project, *Handmade Nation*, looked at a new subculture of "crafters" for whom making things, rather than buying them, is an activity infused with political, emotional, and aesthetic meaning. In taking up the subject of sign painters, Levine is redirecting her attention to a less fashionable group, perhaps, not so much a subculture as a dispersed and informal guild. But she is continuing to show us how practicing a skill can be a whole way of life.

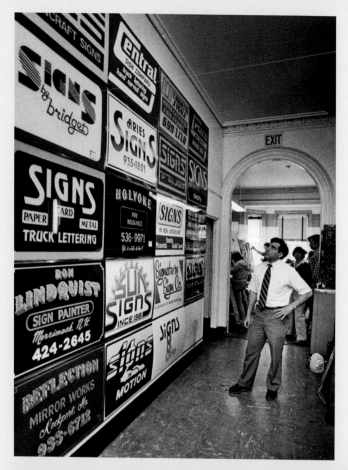

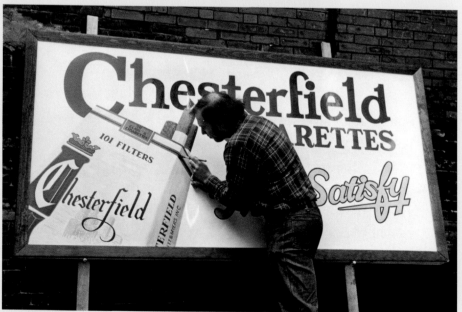

Top and bottom: Butera School of Art, Boston, MA, catalog photos, dates unknown

In settling on this topic, Levine and Macon are just in time. Many sign painters are now retired, or about to hang up their brushes; others have made the transition to easier, cheaper, but depressingly homogenous vinyl lettering or large-scale digital printing. As is so often the case, it is at the moment of a craft's disappearance that its cultural value suddenly becomes plain to see. It's true that hand lettering has been appreciated by artists for decades—think of the 1930s street photography of Walker Evans or the work of 1970s graphic designers like Paula Scher, both drawing inspiration from vernacular sources, finding in them a route out of conventional modernism. But it is only now, as we cross the digital divide, that it seems to make sense to celebrate sign painting. Handmade signage is no longer the norm, as it once was on the streets all over America. It is exceptional, in every sense of the word: the trace of a slower, less hurried era.

Yet it is also important, when paging through this book, not to fall into the trap of nostalgia. In a general sense, sign painting may be in decline. But that doesn't mean sign painters themselves are disappearing. Those who are still working deserve to be taken as the inventive, vital artists that they are, rather than as remnants of a vanishing past. Indeed, it seems likely that after a hard run of years, this trade will go on to have quite an interesting twenty-first century. As with other aspects of handmade culture, it is already taking on new and unprecedented forms—whether in the spirit of revival, the context of artistic appropriation, or simply on its own terms. Yet, while the digital sphere might seem to be the enemy of crafts like sign painting, let's not forget that this work can now be seen worldwide at the click of a mouse. Levine and Macon have gathered the back stories, the rich details of this craft; but you're only one Web search away from seeing many further examples, not only from the United States but also from Latin America, West Africa, India, China—places where the traditions of sign painting are still going strong.

So there is plenty of cause for optimism. In fact, the very existence of this book (and the film it accompanies) is yet another. This is no how-to manual you're reading; although you might pick up the odd tip, it certainly won't tell you how to be a professional sign painter. But you know what? The best response to it might just be to go out, find yourself a board, brush, and bucket, and get to work.

Glenn Adamson
Head of Research at the Victoria and Albert Museum (V&A)

The Sign Painters

Doc Guthrie

I TEACH THE SIGN GRAPHICS CLASS at Los Angeles Trade Technical College. One of the things that LATTC prides itself on is that we teach current technology as well as basic old-school style. The classes are very light on lecture and very heavy on hands-on educational experience; we get people doing things. Like all industries, we've had to change in the past twenty years because of the impact of technology. We can't teach our students obsolete techniques and expect them to compete in the marketplace.

When I graduated from high school I went directly into the navy because I wanted to get out of my house and see the world. When I came back I went to college and then had many jobs and adventures. It was the '60s. It was a lot of fun. Then I met a woman, fell in love, started a family, and had to get serious.

I am a 1972 graduate of the Sign Graphics program. My brother and I took the two-year course and followed the traditional path: we got jobs in sign shops and worked for what I'll call journeymen sign painters—that's the old union term for the accomplished guy, the old pro. We worked in various shops learning shortcuts and techniques and getting some experience.

This was a real creative way to make a living—and notice I said "make a living," not "get rich." If you're under the illusion that you're going to do something like this and get rich, it's not going to happen. If you want to make a good living, and you want to wake up every morning and look forward to the day, look forward to painting a truck, getting up on a wall, painting a movie background, that's a good life. Many people in this country dread getting up and going to work. You have fifty years of work ahead of you, and it should be something that you really love. I never got rich, but I provided a living for my family and owned a home—that's a working-class American success story.

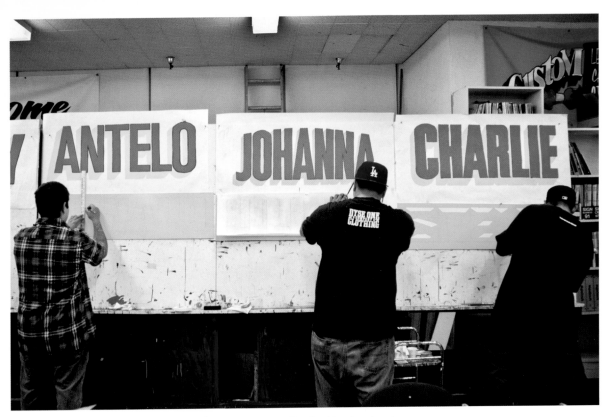

This spread and following page: Los Angeles Trade Technical College Sign Graphics department

Any stranger walking into my classroom would think it's chaos; it looks like chaos, it works like chaos. How it works is a total mystery. The class is very organized and focused. We stay on track and move forward. At the end of sixteen weeks we have another good semester under our belts. The enrollment for the program is now really large. It hasn't always been that way. The word is out that this is a place to come and get serious and learn a fine craft and skill.

We have a wide mix of cultural backgrounds because we are an inner-city school. Students range in age from seventeen to eighty years old. A good portion of my students comes from a graffiti background; there are also professional graphic designers in the class. The majority are men, but there are also women. We all learn to work and make decisions together. It makes for a great experience for all of us.

This is a fascinating job. My students are hard workers. They're talented people, and they want to succeed. They stick with it under the worst conditions—a tyrant for a teacher and strict guidelines to complete the course. It's amazing to see them grow, turn up the volume on their talent, and become accomplished designers and sign painters.

Many people in this
country dread getting
up and going to work.
You have fifty
years of work ahead
of you, and it should
be something
that you really love.

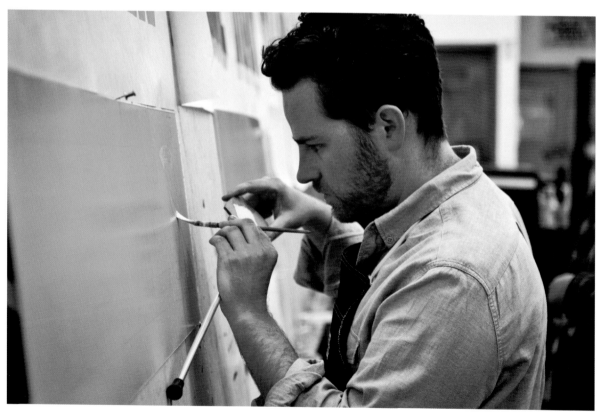

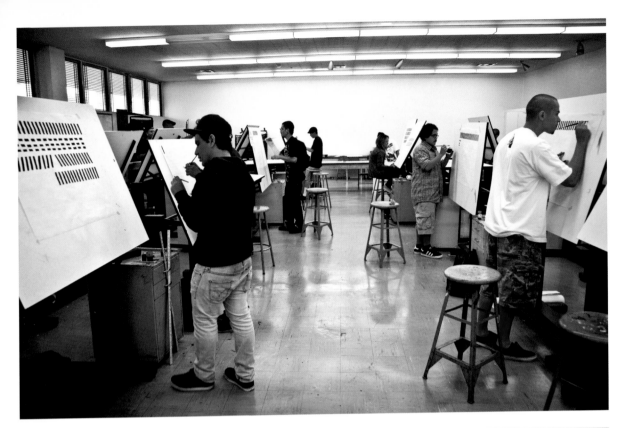

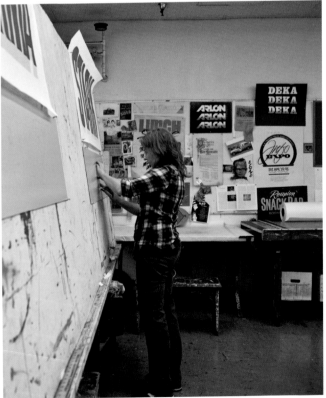

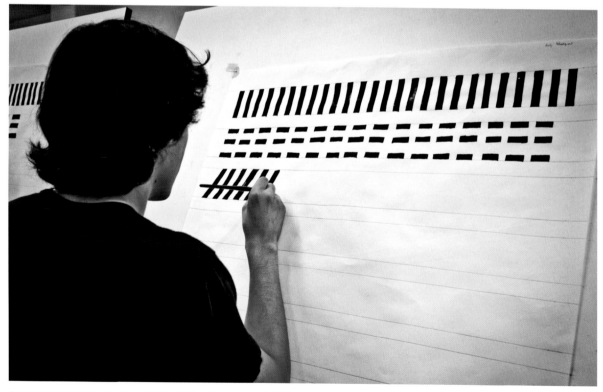

Top and bottom: "The chart," a guideline for the first-semester LATTC students to copy

Sean Barton

THERE ARE DIFFERENT BRUSHES for all types of jobs: liners, lettering quills, stripers for pinstriping. Each brush has its own shape. For example, stripers are shaped like a knife and made for pulling longer lines. If you lay the belly down, the striper holds enough paint so that you can actually pull a line along the side of a car without redipping your brush. Truck brushes are a little bit bigger and work well on trucks but not very well on other surfaces. My workhorse lettering brushes are lettering quills made with squirrel hair. One is manufactured by the Andrew Mack Brush Company, the other by Luco. They have chisel tips. Lettering quills are also made with hog hair, badger hair, and horsehair.

I got into signs when I was just doing art, trying to keep my hands busy. I needed to figure out something to do to pay the bills other than working a regular job. I'd done construction, boat work, a lot of manual labor, but I needed to find something more creative.

I started working with 1 Shot enamel paint about ten years ago. I painted lettering and some art-based work. I had moved up to Bellingham, Washington, and took a couple of small commercial sign-painting jobs. Then I moved back to Seattle and people started asking me to paint lettering on their boats, so I went at it from there.

It seems like people don't want anything permanent anymore. For example, they don't want the permanent lettering on their vehicles in case they end up selling them. It's similar to the mentality of a lot of business owners. They don't want to invest money in their storefronts, but they still want customers to flood in. So many stores have vinyl signs that now entire blocks look the same. Many business owners want to slap up some garbage and still have a bunch of people show up. It just doesn't work that way. If you have a good-looking storefront and you take pride in it, you'll attract more customers. Hopefully there'll be more of a draw to hand-painted signs. I think people's appreciation is growing; business owners see them and want them. They can feel the power of a hand-painted sign.

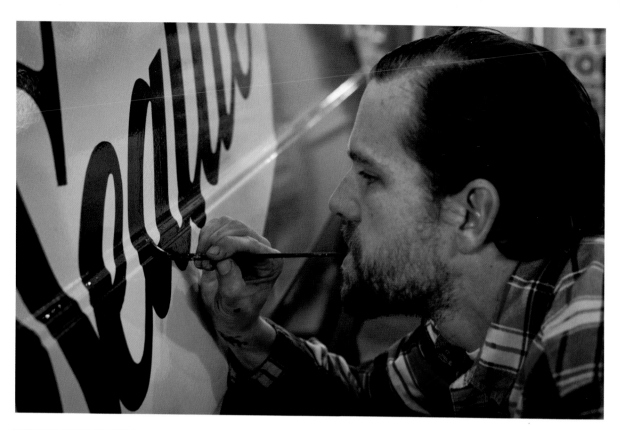

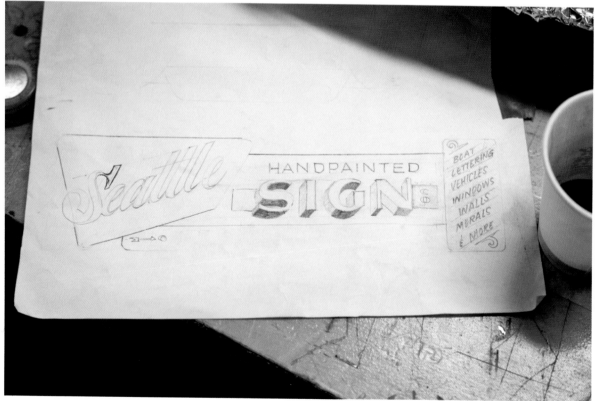

If you have a good-looking storefront and you take pride in it, you'll attract more customers.

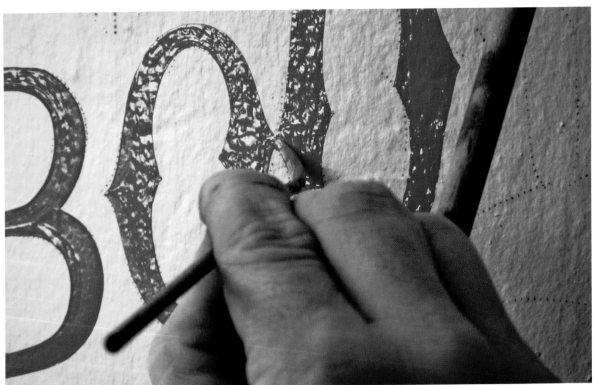

Above (detail) and opposite: THE CELL PHONE BOOTH IS OUTSIDE, Seattle, WA

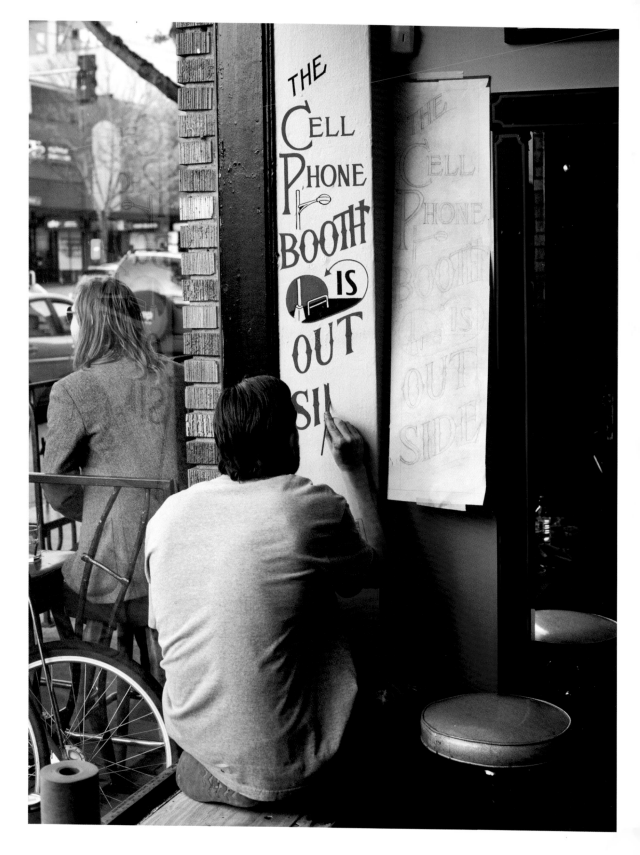

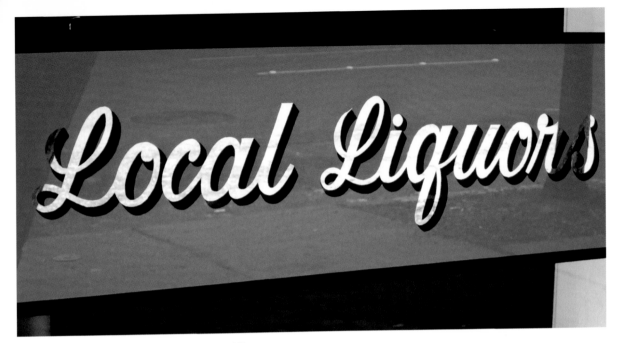

Clever Bottle bar, 14k white gold and enamel, Seattle, WA

Above and right: Sean Barton's sign shop

Stephen Powers

I've always been interested in letters and words. I've loved letters from the cradle.

I'M NOT OFFICIALLY a sign painter because sign painters are at the mercy of their clientele—where they're supposed to paint and how they're supposed to paint. I'm my own client. I can decide what's right and what's best. A sign painter, unfortunately, is in the position of being the arms for somebody else's brain.

I've always been interested in letters and words. I've loved letters from the cradle. It started with graffiti: I wasn't looking at signs, I was into graffiti. Once in a while, I'd see a sign that was special to me. The signs at Coney Island were special to me as a graffiti writer because they advertised pleasure; they had such an irreverent quality. For us graffiti writers, we like what sign painters might call "gingerbread"—the more crap you can throw on a letter, the better.

The reason I segued from graffiti into sign painting was because I'd exhausted a lot of the conventional tactics for graffiti. In sign painting and sign lettering, I found a way of taking graffiti and pushing it in another direction. It wasn't about making good signage; it was about making interesting graffiti and figuring out what it takes to dominate a landscape in a city like New York or Philadelphia. I started using 1 Shot straight out of the can and painting above abandoned storefronts. 1 Shot held a fascination for me because of its strength; it's such powerful paint. I could see there was a world to explore in figuring out how to use that paint correctly.

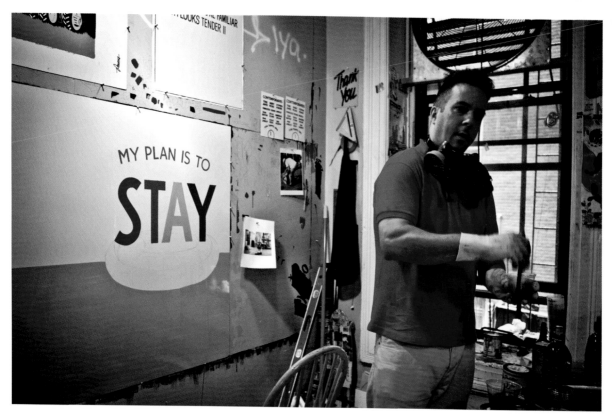

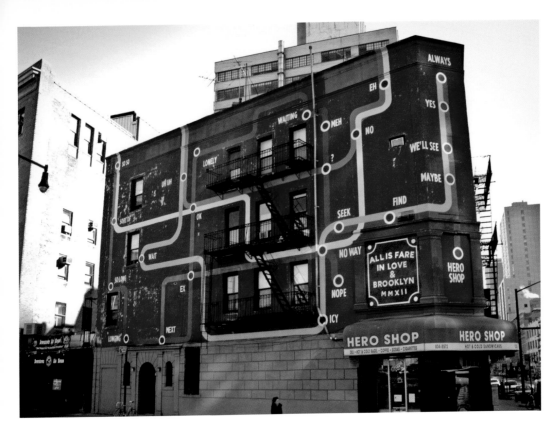

TRAIN TO ALWAYS, Brooklyn, NY, 2012

I didn't know anybody who painted signs. I would try to talk to sign painters, but as soon as they heard I was involved with graffiti they'd get so pissed off. Through a series of wonderful coincidences I met Justin Green, and I had the chance to collaborate with him on a sign-painting project in Cincinnati. Once I met him, I could finally begin the transition from just messing around to doing it correctly in a way that was respectable.

When I paint signs, I work from the point of view of a sign painter. Certain techniques and ways of painting I learned from over one hundred years of sign-painting tradition. What's really cool is that if you follow every known law in the sign game, you'll be a master sign painter. You'll at least learn how to do a sign correctly. You can't really lie; maybe you can cheat a little bit, but you have to tell the truth. I joke with my sign painting coworkers and tell them, "When you do it wrong, it's wrong; when I do it wrong, it's style." For me, sign painting is doing something that graffiti never could: it's impacting people's lives on a monumental scale.

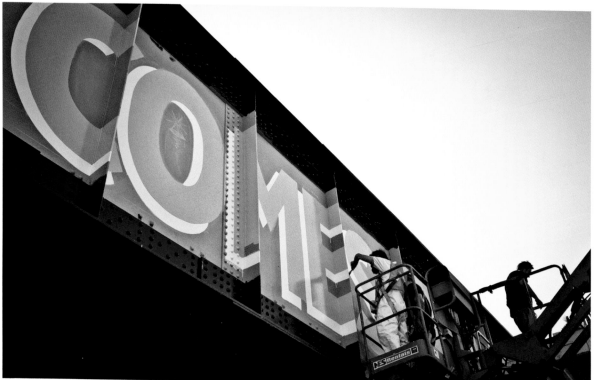

Above: SPRING COMES SUMMER WAITS train trestle in progress, Syracuse, NY, 2010

Justin Green

SIGN PAINTING ISN'T quite an art form. It can be, but the kind of sign painting that I embrace, that I made a living doing, is a service. It's an industry, and I want to keep it that way. I don't believe in gilding the lily. I'm one of the few artists who's also a legitimate sign painter. I had to become a spy in a hostile industry because in the sign industry, when the unions held sway, "artist" was a pejorative term. In all the old sign-painting books the sign painter was referred to as the "mechanic."

I started painting signs at a very late age. When my wife got pregnant she asked me what I was going to do. "What do you mean? I'm a cartoonist, I'm pretty well known," I said. "No, what are you going to do for money?" she asked. "Well, I'll paint signs." I had no idea where that was going to lead me because in the old days, sign painters were like matadors: they started training at the age of thirteen or fourteen. I really had to learn in a hurry; I had a crash course.

> **Before the advent of vinyl, a sign painter was an interloper in every strata of society.**

Before the advent of vinyl, a sign painter was an interloper in every strata of society—and I mean that literally. One day you'd be on your knees lettering an industrial roll-up door with the words TOW AWAY and the next day you'd be on the thirty-fourth floor of a bank's head-quarters painting gold leaf. Every strata of society valued your skill. It was phenomenal. As I was learning to paint signs, guys who were my age or a little older were retiring and gave me a lot of invaluable tips. I owe much to them, and out of a sense of responsibility I started a cartoon strip called *Sign Game*. Tod Swormstedt insisted that the cartoon appear in *Signs of the Times* magazine.

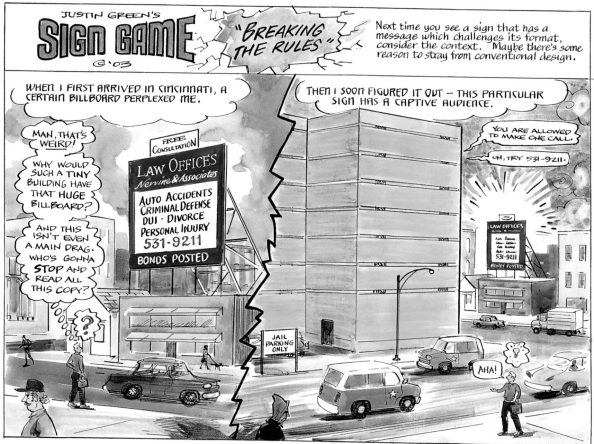

Above and following pages: *Sign Game*, a monthly cartoon strip printed in *Signs of the Times* magazine

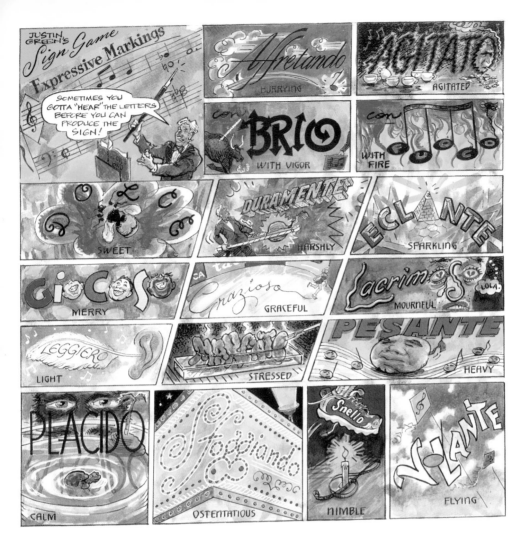

I wanted to be an anonymous craftsman. I wanted to be a so-called benchman with plenty of work to knock out without getting my ego in the way. But those jobs totally dried up with the computer. They disappeared from architectural rendering, medical illustration, interior decoration, you name it—anything that requires intuitive use of traditional tools involving eye-and-hand coordination has now been subsumed by this infernal machine. Technology won.

This story has to be told. A whole aesthetic and artistic vision is disappearing as we speak. Sign painting still exists, although in a very constrained way. The eulogy that I'm delivering is for the all-around work. I was an all-around man and there's something to be said for that, someone who can do paper signs, gold leaf, pictorials. I still do the occasional sign, but my vision of jumping off a billboard at age seventy-five isn't going to come true, unfortunately, because there are no more hand-painted billboards—except in New York, and even there the signs are almost all digital.

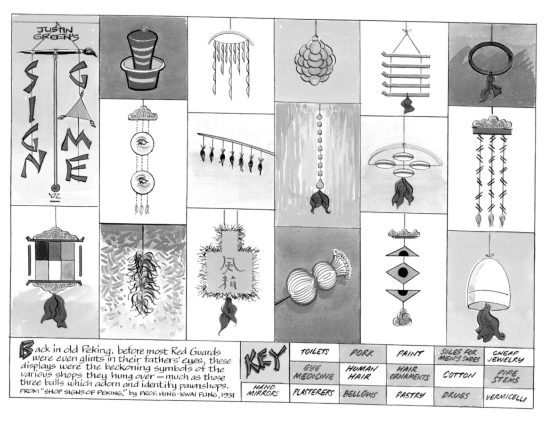

Back in old Peking, before most Red Guards were even glints in their fathers' eyes, these displays were the beckoning symbols of the various shops they hung over — much as those three balls which adorn and identify pawnshops.
FROM "SHOP SIGNS OF PEKING," by PROF. HING-KWAI FUNG, 1931

KEY					
TOILETS	PORK	PAINT	SOLES FOR MEN'S SHOES	CHEAP JEWELRY	
EYE MEDICINE	HUMAN HAIR	HAIR ORNAMENTS	COTTON	PIPE STEMS	
HAND MIRRORS	PLASTERERS	BELLOWS	PASTRY	DRUGS	VERMICELLI

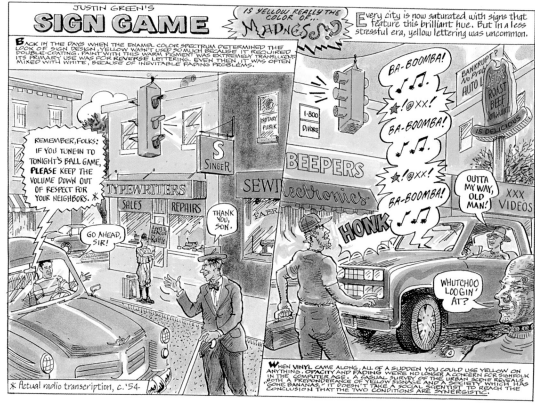

JUSTIN GREEN'S
SIGN GAME
IS YELLOW REALLY THE COLOR OF... MADNESS!?
Every city is now saturated with signs that feature this brilliant hue. But in a less stressful era, yellow lettering was uncommon.

Back in the days when the enamel color spectrum determined the look of sign design, yellow wasn't used so much because it required double-coating. Paint with this warm pigment was extremely translucent. Its primary use was for reverse lettering. Even then, it was often mixed with white, because of inevitable fading problems.

REMEMBER, FOLKS: IF YOU TUNE IN TO TONIGHT'S BALL GAME, PLEASE KEEP THE VOLUME DOWN OUT OF RESPECT FOR YOUR NEIGHBORS. *

GO AHEAD, SIR!

THANK YOU, SON.

TYPEWRITERS SALES REPAIRS

LITTLE LEAGUE Raffle

S Singer

SEW

NOTARY PUBLIC

1-800 DIVORCE

BA-BOOMBA!

!@xx!

BA-BOOMBA!

!@xx!

BA-BOOMBA!

HONK

BEEPERS
Electronics

BANKRUPT? No prob AUTO L...

ROAST BEEF ...IS DELICIOUS

OUTTA MY WAY, OLD MAN!

XXX VIDEOS

WHUTCHOO LOOKIN' AT?

* Actual radio transcription, c. '54

When vinyl came along, all of a sudden you could use yellow on anything. Opacity and fading were no longer a concern for signfolk in the computer age. A casual survey of the urban scene reveals both a preponderance of yellow signage and a society which has "gone bananas." It doesn't take a social scientist to reach the conclusion that the two conditions are synergistic.

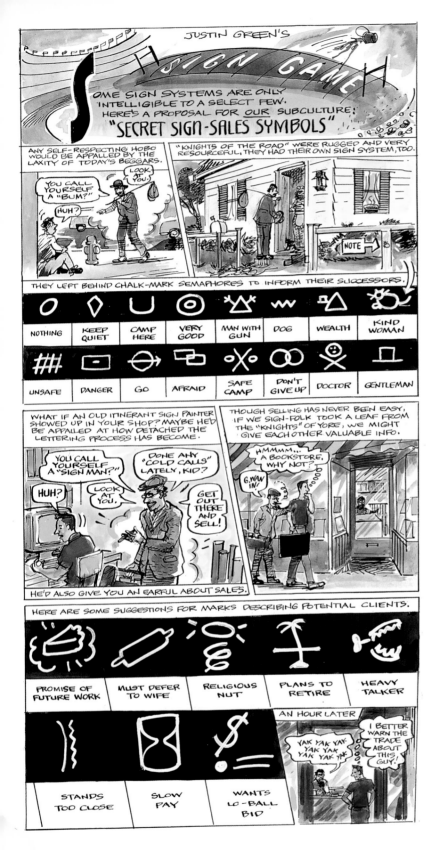

JUSTIN GREEN'S SIGN GAME

TODAY I SING THE PRAISES OF COMMON SHELLAC

MORE THAN A MERE SOLVENT, ITS THE SIGNMAN'S ELIXIR

Thanks to R. Glawson

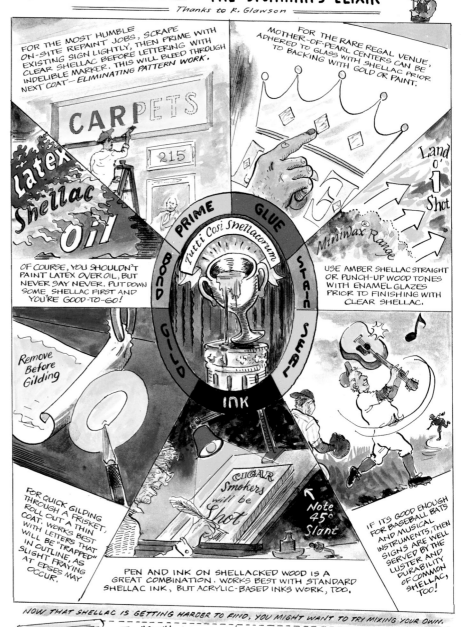

FOR THE MOST HUMBLE ON-SITE REPAINT JOBS, SCRAPE EXISTING SIGN LIGHTLY, THEN PRIME WITH CLEAR SHELLAC BEFORE LETTERING WITH INDELIBLE MARKER. THIS WILL BLEED THROUGH NEXT COAT— ELIMINATING PATTERN WORK.

CARPETS
215

FOR THE RARE REGAL VENUE, MOTHER-OF-PEARL CENTERS CAN BE ADHERED TO GLASS WITH SHELLAC PRIOR TO BACKING WITH GOLD OR PAINT.

Latex Shellac Oil

OF COURSE, YOU SHOULDN'T PAINT LATEX OVER OIL, BUT NEVER SAY NEVER. PUT DOWN SOME SHELLAC FIRST AND YOU'RE GOOD-TO-GO!

Land o' 'i' Shot

Miniwax Range

USE AMBER SHELLAC STRAIGHT OR PUNCH-UP WOOD TONES WITH ENAMEL GLAZES PRIOR TO FINISHING WITH CLEAR SHELLAC.

BOND — PRIME — GLUE — STAIN — SEAL — INK — GILD

Tutti Cosi Shellacorum

Remove Before Gilding

FOR QUICK GILDING THROUGH A FRISKET, ROLL OUT A THIN COAT. WORKS BEST WITH LETTERS THAT WILL BE "TRAPPED" IN OUTLINE, AS SLIGHT FRAYING AT EDGES MAY OCCUR.

CIGAR Smokers will be Shot

Note 45° Slant

PEN AND INK ON SHELLACKED WOOD IS A GREAT COMBINATION. WORKS BEST WITH STANDARD SHELLAC INK, BUT ACRYLIC-BASED INKS WORK, TOO.

IF ITS GOOD ENOUGH FOR BASEBALL BATS AND MUSICAL INSTRUMENTS, THEN SIGNS ARE WELL SERVED BY THE LUSTER AND DURABILITY OF COMMON SHELLAC, TOO!

NOW THAT SHELLAC IS GETTING HARDER TO FIND, YOU MIGHT WANT TO TRY MIXING YOUR OWN.

You'll need
- ✓ Shellac Flakes
- ✓ Denatured Alcohol
- ✓ Cheesecloth
- ✓ Container with lid

The **"Cut"** is determined by the ratio of flake to alcohol. A thin "1 lb. Cut" is 1 lb. flake to 1 gal. alcohol.

Qt. ~ ¼ lb. to Qt. alcohol
Pt. ~ ⅛ lb. to Pt. alcohol

Combine flakes and ½ of the total alcohol. Store mix for at least 24 hours, stirring occasionally.

PICKLES
A DARK JAR IS BEST

When dissolved, add the rest of the alcohol. Stir and pour through a cheesecloth.

Stir again & let stand for 2 hours.

JUSTIN GREEN 43

Mark & Rose Oatis

You have to learn how to look ahead of where you are.

MARK: This adventure has been unfolding for thirty-odd years. We met in Denver at Jerry Albright's Sign School, where Rose was an apprentice and I was a newly admitted journeymen back in the late '70s. Jerry Albright, a great legendary figure, was our teacher. He was really skilled—show cards, gold leaf, track lettering—you name it. His level of craftsmanship was very high.

In 1971 I entered the Union Apprentice Sign Painting Course, which was a five-year program. I began working for the Denver Sign Company and became acquainted with other apprentices in the trade. We'd get together in one of the shops to talk about what interested us: design trends, old techniques, and the stuff we read about in sign books—methods that weren't being taught in the shops where we were working.

So, the seven of us—Mike Rielley, John Frazier, Earl Vehill, Rick Flores, Bob Mitchell, Noel Weber, and myself—started this little club. One night we'd work on gold leaf, another evening we'd bring in somebody who was very skilled at show cards. We did this informally for about six or seven years. Sometimes five people would show up and sometimes twenty. Earl Vehill coined a name for us, "Letterheads." We began communicating through articles in magazines, letters, and by phone since it was pre-Internet. The Letterheads connected people from around the country, and that's how it began to grow. There are still Letterhead meet-ups that reflect our first get-togethers in Colorado around the world to this day.

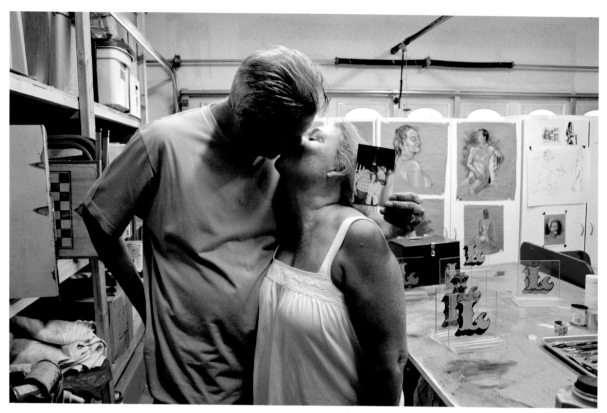

Mark and Rose in their studio mimicking the 1983 photo Mark is holding

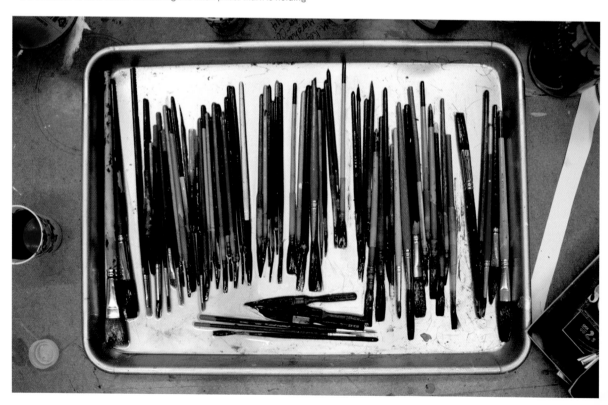

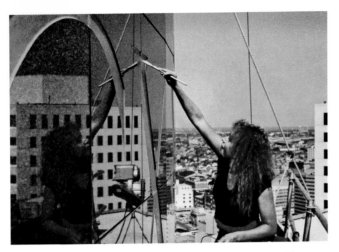

Thirty-eight-story building, gold leaf on granite, New Orleans, LA, 1983

Rose gilding the words "I will invest my money in people," Kellogg's headquarters, Battle Creek, MI, 1986

The guys at the sign shops said that I was too small and short (I was), that I couldn't carry my ladders, I couldn't do this, I couldn't do that. They basically said that they'd hire me to sweep the floors and make coffee, but as a woman I wasn't going to be working in the world as a sign painter.

ROSE: In 1979 I was living in Chicago, where I saw a couple of big walls being painted. I just couldn't believe what they were doing. There was this great big wall across from the bank with advertising painted on it. One day I went to the bank and noticed that they were coating it in white and I thought, that's weird. The next day I went back to the parking lot, and the painters were hanging up there, adding the patterns. I went back every day and watched them paint this big piggy bank with dollars and coins exploding out of it. One day I caught the sign painters at lunch and asked, "So how do you go about doing this?" They told me that I needed to enroll in an apprenticeship program.

I found Jerry Albright's School. I worked with the master for five years. After the apprenticeship, he tagged on six months for students who wanted to learn gold-leaf techniques. There were probably three or four women in my class, and it was very hard to get a job. The guys at the sign shops said that I was too small and short (I was), that I couldn't carry my ladders, I couldn't do this, I couldn't do that. They basically said that they'd hire me to sweep the floors and make coffee, but as a woman I wasn't going to be working in the world as a sign painter.

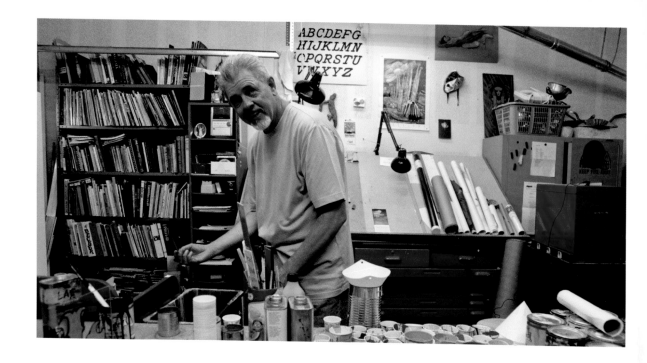

MARK: Some of the greatest designers I know work on a computer. They stay up at night thinking about what they're going to do the next day. They're every bit as obsessed, every bit as skilled, and they have an arsenal of tools available to them, but there is a visceral attachment to working by hand. The craft is difficult to learn and master. You have to learn how to look ahead of where you are; whether you are lettering or whether you are pinstriping, you literally can see the letter before you paint it. It takes a lot of practice. It seems like a computer deprives you of that basic contemplative groove that you get into when you work.

Years ago I was coming off of a forty-eight-hour shift with a buddy, and he said, "I've got it. I know exactly how much importance the average person places on what we do. We are like professional bowlers." He said the average person thinks about a sign painter as often as he thinks about somebody playing on the pro-bowling circuit.

Six months later, Rose and I were flown to St. Louis, Missouri, to present a job proposal in front of some architects. We showed a sample box full of exotic glass pieces. The job was for an art deco–style riverboat docked in St. Louis called the SS *Admiral*. The pieces of glass spelled out "The Admiral." We proposed various finishes for the signs: gold leaf, both matte and bright gilt, in all karats of leaf from 24k on down. We had a little custom oak box made in which we carried and stored the glass samples. This was a pivotal project in our career. I remember saying, "Honey, I think we've arrived." So we get out of the taxi, and we're standing on the sidewalk, and we look up and realize that we're standing in front of the Professional Bowlers Association Hall of Fame. We ended up getting the job, and the signs were done back in our little shop in Denver.

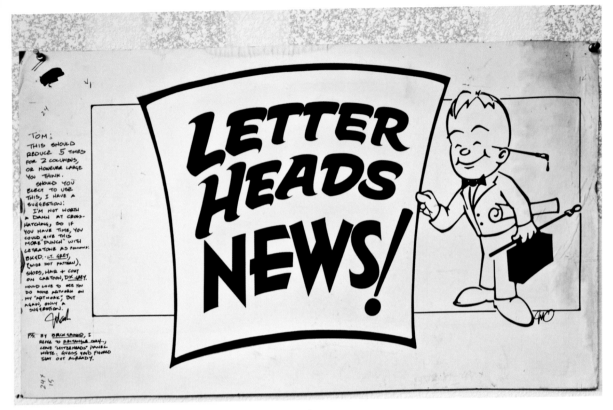

Original show card designed by Mark and used in *SignCraft* magazine, 1981

Letterhead project, Indiana, 1998

The Letterheads connected people from around the country, and that's how it began to grow. There are still Letterhead meet-ups that reflect our first get-togethers in Colorado around the world to this day.

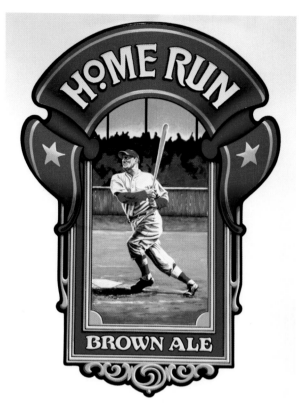

Home Run Brewing Company, Denver, CO, 1991

Bob Behounek

I'M RETIRED NOW, but my shop is where I do all my pinstriping, miscellaneous lettering jobs, and an awful lot of charity work. My story starts with model cars, probably when I was ten years old. We'd go to the race tracks around Chicago and see race cars and cool hot rods on the street. All these cars were painted by hand by the generation before, and I couldn't help but want to learn how to do that.

When I got older I went down to the Local 830 Sign Pictorial Union hall in Chicago, and I applied for a job. After waiting about a year and a half I got a call. The union offered me three different shops to work in. I chose the small shop where they did a lot of hand lettering and show cards because I knew that they would give me a brush and I was going to paint right away.

Shortly after that I enrolled in the five-year apprentice program at Washburne Trade School, which was run by Ken Malar through the Chicago School District. That's where all the unions had their apprentice programs. Ken was the head designer along with three or four other guys at Beverly Sign Company back in the '60s.

Our class spent a year and a half just drawing lettering before we actually picked up a brush. Ken would come by with a red pen and mark what we'd drawn incorrectly to show us what had to be fixed. It gave me a rock-solid foundation. You need to know the rules to be able to break them.

I was lucky to be on the tail end of what I would call the golden era of the '50s to the '70s. I was fortunate to be able to learn from the people who worked at the Beverly Sign Company and the other shops in Chicago. In the '80s we brought our work to another level, which started to increase the value of signage citywide. *SignCraft* magazine was interested in what I was doing because I was using old principles in a new generation.

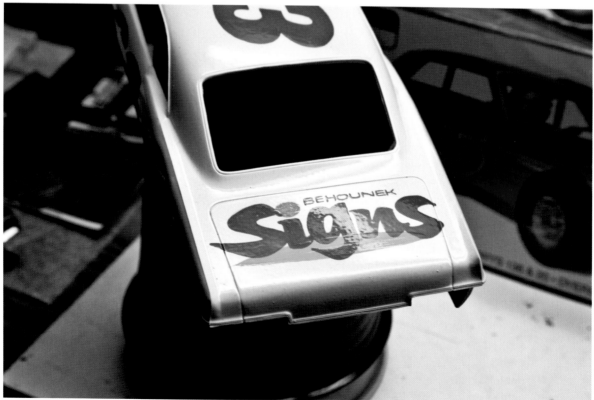

Above and opposite: Hand-painted roadside advertising billboards

Vinyl machines can cut, they can give you a circle and a square, but they can't give you the passion of a sign painter.

At this same time, bigger and better vinyl machines became available. People were getting into the sign business just to make money. Now there are more of those sign shops—businesses that give no thought to design, color, how a sign is going to appeal to people walking by—than real sign painters. There are more people out there now who don't understand or don't have the passion to create a well-designed sign. Vinyl machines can cut, they can give you a circle and a square, but they can't give you the passion of a sign painter. Now sign makers are just printing colored ink on white vinyl. They're not even cutting out letters anymore. They're wrapping vehicles in these kinds of signs.

The cityscape started to change in the '90s when people got a hold of vinyl-cutting machines. That's why we are seeing the homogenization of advertising styles on the roads and highways of North America. I can see the history produced in 1960 because somewhere there is a truck or a sign on a wall that's still there. But I have a feeling that ten years from now, a car that somebody wrapped in vinyl will no longer exist. We'll never see the history of much of what's produced now. That's the part that's really sad.

Above: Beverly Sign Company job sketch, date unknown, collection of Bob Behounek

Left and opposite:
Trucks, a vehicle lettering manual published
in 1992 by SignCraft Publishing Co., Inc.

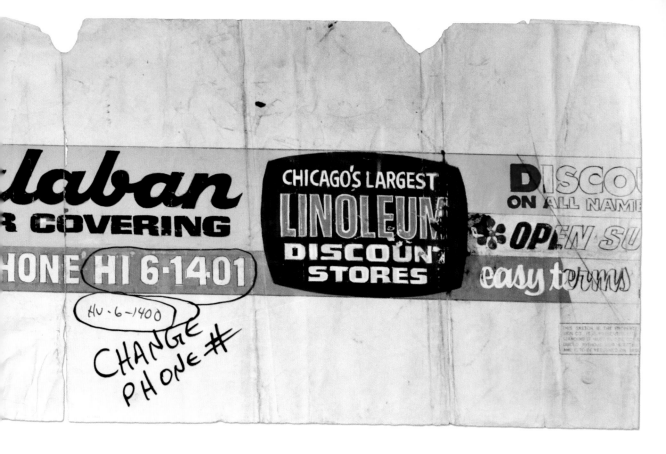

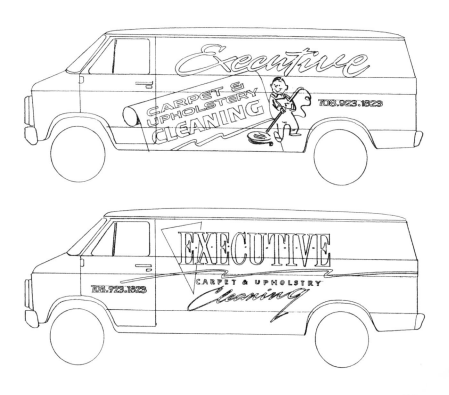

Norma Jeanne Maloney

—

There's some fear involved in doing what you love. I get up every morning and I look at that fear and say to myself, "I'm doing what I love today."

—

MY DAD WAS IN THE ARMY, so we traveled around quite a bit. I was allowed to pick where we stayed based on the motel sign. My dad would ask, "Where are we staying, Norma Jeanne?" and I'd say, "I like the color TV part of that sign, let's stay there." Even as a small child I had a fascination with typography, which was completely abnormal. As a teenager I'd draw ornate album covers, like Fleetwood Mac and Bob Seger. I was in love with type.

Mike Stevens was one of the best sign painters that I had the opportunity to meet. He was teaching a sign class in Lexington, Kentucky. It was really expensive for me at the time. I arrived on the first day and no one else was there, not one other student. He had coffee, doughnuts, and brushes all lined up. He was devastated. He said that he didn't think he could teach the class with just one student. I begged him not to send me away. I told him that I'd been looking forward to the class for weeks. "I can see that you have a fire in your belly," he said. "Let's do this thing." I was his student for two weeks, and then he passed away suddenly.

I never had the chance to finish the class and didn't know him well, but I was invited to his funeral. At the ceremony his daughter came up to me and asked if I was Norma Jeanne. She said that she wanted to show me something. She had his journal, and he'd been writing about me. He'd written, "This girl is going to be a great sign painter." I'd been ready to give it up, thinking it was never meant to be, since I just kept hitting obstacles. That was a powerful moment.

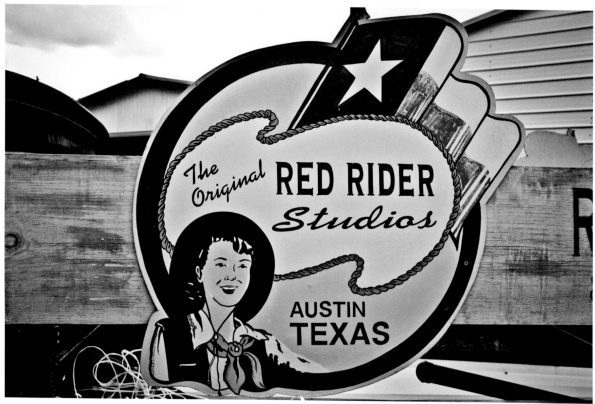

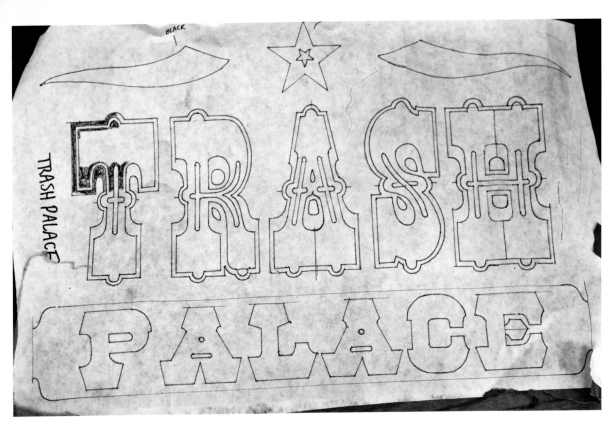

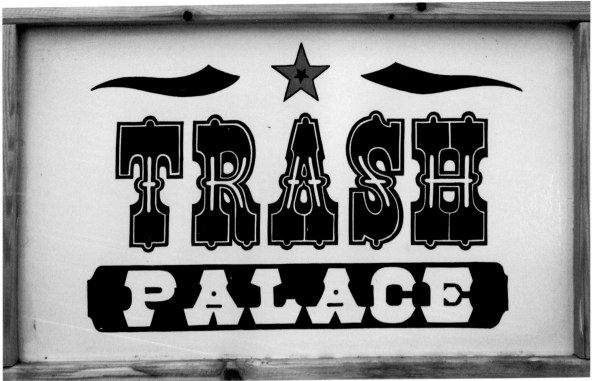

Top and bottom: Trash Palace pattern and finished piece, 2011

Even as a small child I had a fascination with typography, which was completely abnormal.

I opened Red Rider in 1996 in San Francisco a block away from New Bohemia Signs. There was a funny competition going on between us at the time. New Bohemia would put a sign in its window, like THE REAL DEAL. Then I would paint THE REAL MCCOY in my window. I finally walked over there and said, "This is ridiculous. We are in San Francisco. There is plenty of work, this feud has got to stop."

I ran free sign-painting classes in the Mission when I lived there. If anyone wants to learn how to hand paint signs, I say the more, the merrier. There are people who came to those classes who are sign painters now, or who are incorporating those lessons into their art. Of course, they didn't start out doing it right; I didn't do it right, either. When I look at some of the signs I first painted, which are unfortunately still around in Kentucky, they're horrible. But the people who paid me to do them thought they were great, and it made me feel good. Every time I painted one, I learned what I was doing wrong.

Red Rider was immediately successful because of where it was located in the Mission. When I first opened the doors I didn't have any work, so I spent all my time making it the most beautiful storefront possible. People in the neighborhood would walk by, and that's how I got work. It was all word of mouth. I had a '42 Chevy pickup truck, which people would recognize. "You're that sign painter chick with the cowboy hat in the red truck."

I had close relationships with my clients; I really wanted them to succeed. When you start a business, sometimes the last thing you think about is your sign. Often someone would come to me and say, "We open in two weeks, we really want you to paint our sign, but right now we can't afford it." Sometimes it would be a fancy restaurant or a grocery store and the owner would offer some cash and some barter. I bartered a lot. I would rather do that than turn work away. And it's cool because when I go back to San Francisco, my work is still there.

I was homesick and decided to leave San Francisco and ended up in Nashville. When I got there I literally walked up to a bar owner and said, "I heard you don't have any money. I'll paint your sign for free." I knew once I was up on the ladder and everyone saw me painting, I'd get more work. I was right; people came out of the different honky-tonks asking if I had a business card. I painted Lower Broadway in about three months. I was basically done painting Nashville, and I'd always heard that Austin was a perfect marriage of Nashville and San Francisco. I went to check it out and could not believe how visually stimulating it is. People really care about their storefronts and about how things look, regardless if it is a food trailer or an ice cream truck. It was the perfect place to relocate my business.

When I started painting signs Mike Stevens told me that it was a difficult time to become a sign painter. With the popularity of the vinyl machine, it was a risky decision to make a career of sign painting. At the time I didn't necessarily know it was going to be my career. It's astounding to me how many people dropped the brush and bought a machine. Hundreds of sign painters just threw in the towel. They'd been hand lettering for years and then said, "Well, we have this plotter that will cut out letters for us. It's faster and there's more money in it, we might as well." How do you walk away from your craft like that? I can't wrap my brain around it.

Marquee on "Honky-tonk Row," Nashville, TN, 2002

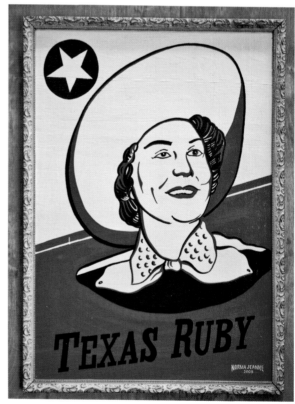

There's some fear involved in doing what you love. I get up every morning and I look at that fear and say to myself, "I'm doing what I love today," and that gets me through the day. I work really hard for a living. I work with my body, and I'm feeling it. There are tough times; I don't punch a time card and receive a check every two weeks. I can be rolling in signs every day for five months, and then there is no work for three months. You need to be a certain kind of person to handle that.

Gary Martin

> I love my work
> to look like it's hot
> off the press,
> like you can still
> smell the paint.

I STARTED SIGN PAINTING in Austin, Texas, in the late '70s. I was around thirty years old, and there was a huge recession. I didn't have much money and was looking for a job. One day I was walking down the street and saw somebody loading signs into a truck. He looked like he was struggling, so I asked if he needed help. I loaded some signs and started talking to him. I told him that I needed a job, that I was kind of an artist. So I got a job in a sign shop, and all they did was cut and frisket, which was a stencil-based process some shops used at the time. Then Greg Jones, a local sign painter, came into the shop and said, "You're doing it the stupid way." "Well, show me the smart way," I said. He showed me some sign painting, and gave me a little bit of instruction. I really liked it, so I got a job in an actual sign-painting shop.

At the time I thought that if I wanted to become a really good sign painter, I'd have to go to a big city. I'd already lived in San Francisco in the late '60s, so I decided to move back there. I got a job in a big downtown shop that did all the fancy work for the well-known lawyers and doctors. In those days, the lawyers and doctors had gold-leaf signs, and every time one of them died I had to record the person's name on the deceased list and then realphabetize and repaint all the names from top to bottom. So there was a lot of gold-leaf work back then.

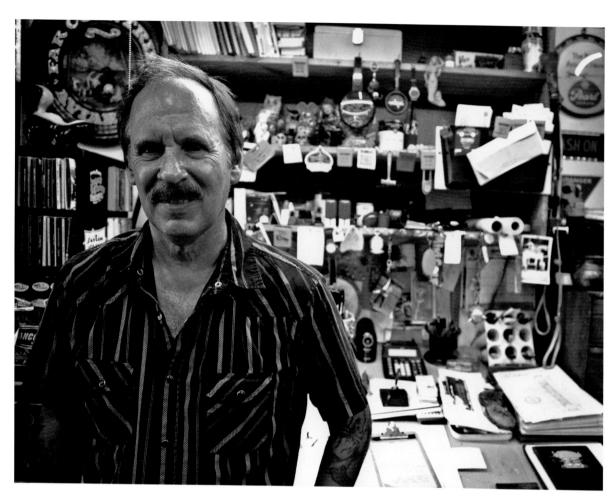

I used to be just one sign painter among other sign painters. Then there were years where I was a sign painter all by myself. Everybody else did vinyl letters and laughed at me. They said, "What are you doing? Get hip." I didn't want to; I would've rather sold key chains and personalized ballpoint pens than make vinyl signs. So I just kept painting signs, and it paid off. I'm not rich or anything, but I made the right decision.

I love my work to look like it's hot off the press, like you can still smell the paint. My customers come to me for one reason: they want my work. I'm a visual influence on the streets of Austin, and I like that. People from out of town are always ordering signs, and I have to ship them out. I wish that work could stay local because I don't get to see it out on the streets.

I'm extremely happy. I feel like I've been living on a desert island by myself for years and then all of a sudden a bunch of other people started showing up to join me. I weathered it, and since the new wave of these younger sign painters started getting involved it makes me work and try harder. It has energized me so much. Now I can post my stuff online and get reactions from other sign painters. When I'm designing a sign I'm thinking, "Okay, this will be seen by a lot of people who have discriminating eyes. I have to make this good."

FOR A LIMITED TIME ONLY!

CARAMEL

Milkshakes $1 85 +TAX

Howdy STRANGER

• HOURS •
11am-10pm
SUNDAY 11-9

MARTIN SIGNS

WELCOME

NO CHILDREN
NO DRUNKS
NO CHECKS
NO BULLSHIT
DEPOSITS ARE
NON-REFUNDABLE

MUST BE EIGHTEEN~
TO BE TATTOOED

I would've rather sold key chains and personalized ballpoint pens than make vinyl signs.

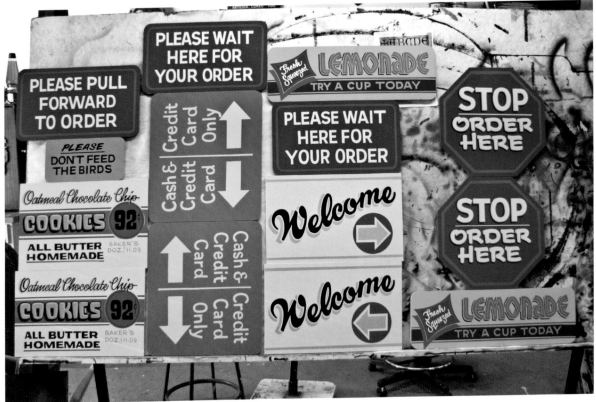

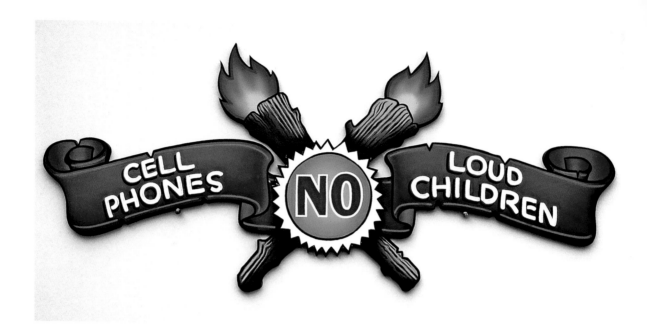

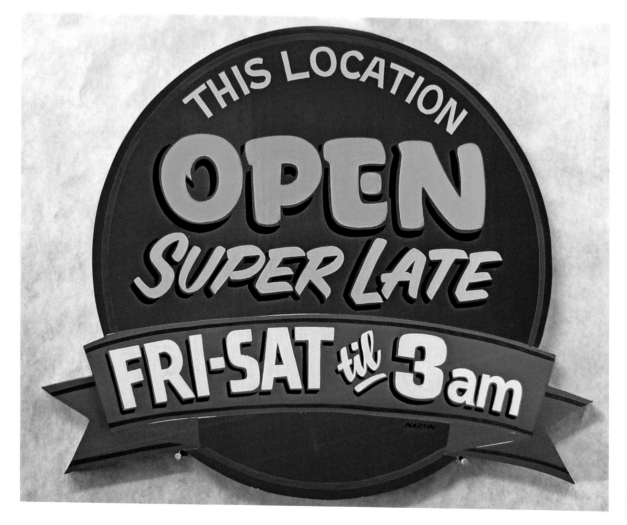

Ira Coyne

The most valued objects
of lost cultures are
the things that were made
by hand. We need to
start making things with
our hands again.

WHEN I REALIZED that I wanted to be a sign painter in my early twenties, I knew I had a very long road in front of me. I still do. Before I established a reputation, my method was to draw and paint and build a portfolio. I literally went door-to-door for five or six years before work started to become steady. I didn't have anyone to teach me how to do this. I had to do it old school; I had to hustle like a salesman and fake it. I went into local businesses that have now been my customers for over ten years and said, "I'm a sign painter. I can paint your sign." I had no idea how to do it, but I figured it out along the way. Now I don't have to look for work anymore. Now people come looking for me.

Signs used to be painted to last a lifetime. A couple of generations ago, when people started businesses, a sign was a permanent thing. A guy could pass on his business to his family. That doesn't happen anymore. Business owners don't paint their buildings for the same reason that they don't paint their cars: because often they don't even own them, the banks do, and they have to think about reselling in case they go under. The businesses that I've developed good relationships with understand how important it is to look different from everybody else. If you go to a cookie cutter sign company that's going to print out something from the computer, with all the R's looking exactly the same, it just won't have as much character.

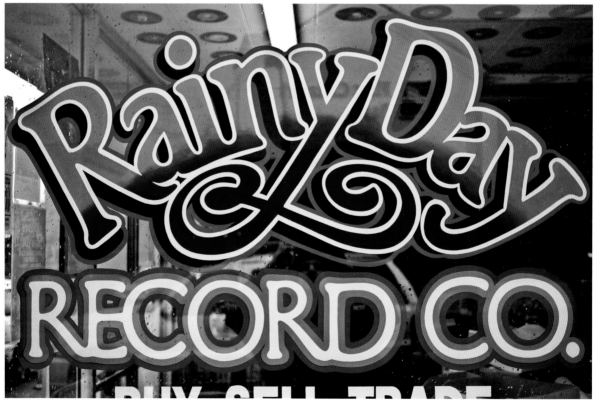

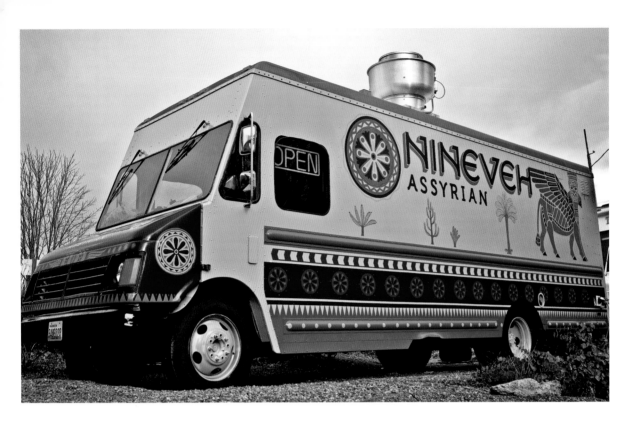

Sign painters got pushed out of the industry. The union dissolved, the technical institutes that taught sign painting went under, and the schools that kept their doors open started teaching on computers. Sign painters became insular as their empire crumbled. It was a thirty-year process that pushed out the sign painter. Now a select few are picking up the pieces and trying to rebuild the industry, but the pieces aren't going to fit back together the same way. It's going to be a mixture of different techniques and new ideas. Now you'll meet sign painters who do hand-painted art but from computer-generated graphics—they use a combination of both.

When people ask, "Oh, what do you do?" I say that I'm a sign painter, that I paint letters on buildings. But that's not all. I have to be able to do everything. Sign painting includes every form of art—it's lettering but also murals, realistic painting, surrealistic painting, comics. Comics are a huge influence on sign painting; almost all the old sign painters were also comic artists and illustrators.

Some people spend their entire day in an office thinking about code. A lot of my friends work for computer or graphic design companies creating code for websites. "What is code?" I ask them. They tell me that it's the computer's language of communication—whatever that is, I still don't know. I can't wrap my mind around the fact that people sit in an office and code eight hours a day.

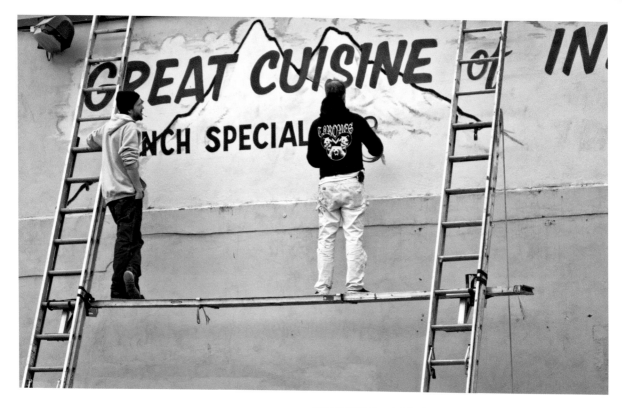

Sign painting creates jobs—more importantly, jobs for artists. Art and music are the first things to go in schools. The role of art is disappearing. When we were kids, we learned about bakers and candlestick makers. We learned about cobblers and all these old-school, awesome things that people did their entire lives. They specialized in making one thing. Today the things that are made are not meant to last, they're temporary, but the by-product of that is not temporary at all. It's detrimental to our environment.

Computers are obviously important, they have an important role, but to put all of our faith in something that isn't real is an illusion. In archaeology, the things that matter most are handmade: ceramics, glass, sarcophagi, paintings. The most valued objects of lost cultures are the things that were made by hand. We need to start making things with our hands again.

This page: GREAT CUISINE OF INDIA painted with Sean Barton, Japhy Witte, and Vince Ryland

Roderick Laine Treece

It's ironic to get
paid to make
things appear faded
and beat up.

MY FATHER WAS a sign painter. He was the head of the sign department at Knott's Berry Farm, in California. There were always pieces of signs around when I was growing up, fragments that I didn't know were signs until he got done with them. I remember there were these little blocks of wood lying around for months. He'd finish the sign, and all the blocks of wood became the standoff for the lettering, which was used to bring the lettering forward from the background to create depth.

When I was a kid there wasn't a fence around Knott's Berry Farm. I could literally walk around the park at six o'clock in the morning. Any kid in his right mind would want to go inside the rides, which I did. I would get caught and then dragged out by security. As a form of punishment my dad would bring me men's and women's restroom signs. He'd say, "Here's your brush, here's your paint, now repaint these." At first I did a terrible job, but I got better. That's how I learned how to paint signs, starting at the age of twelve.

I didn't plan on becoming a sign painter. I wanted to be a photographer. It wasn't until I graduated from high school, got a real job, and got fired that I realized I knew how to paint signs. That's when I started my own company. I painted in Southern California for about five years and then started to get antsy. Back then I never stayed anywhere for longer than a year. Being a "snapper" (industry slang for a traveling sign painter) was perfect because you could be on the road and work. I wasn't making a lot of money, but I was traveling around and having a ball.

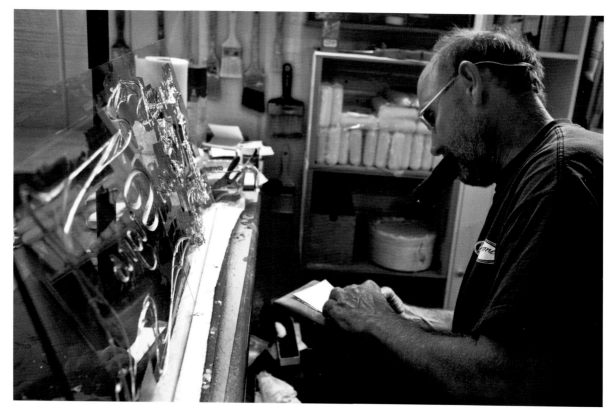

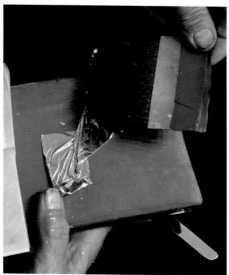

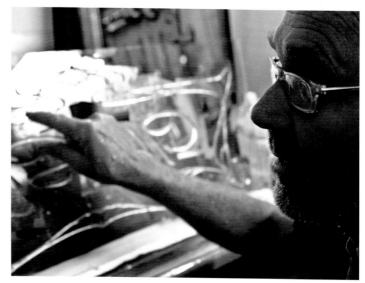

This page: Reverse glass-gilding demo at the Brouhaha Letterhead Gathering, Big Bear Lake, CA, 2011

Around this time I saw a florist shop with beautiful gold leaf painted on the window. I called my dad that night, told him that I saw the gold-leaf sign, and asked him how to do it. He described the process, but I had no concept of what he was talking about. My dad was a pack rat. I discovered that he had all the gold-leaf supplies, and when I figured out how to use them I immediately fell in love with the technique.

Doing gold-gilded glass signs didn't become a full-time passion until I met Rick Glawson. He was completely dedicated to gold; I think at some point he told all of his clients, "Listen, we're not doing anything else but gold." That inspired me, and it wasn't until he died that I decided to focus my entire business on gold.

A New York designer for Ralph Lauren approached me because he wanted handmade glass signs for a new store designed to look like it was from the 1800s. He wanted the mirrors to seem as authentically turn of the century as possible. A lot of the artwork had been designed in Photoshop, which gave it a stiff look. We changed a lot of that by hand. We re-created signs that looked like they were one hundred years old. I had to pick apart all of these techniques. It's one thing to see something old and in beautiful, pristine condition and re-create it. But it's another thing to figure out how it has worn itself away and to replicate that process. It's ironic to get paid to make things appear faded and beat up. That's part of what being a sign maker is and always has been. It's about following the trends and creating whatever people want.

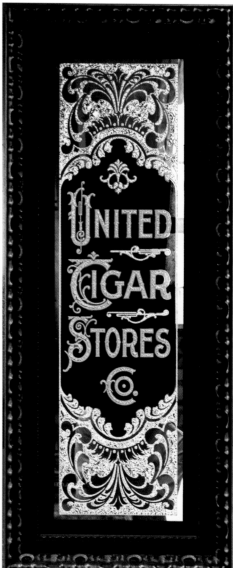

A lot of the artwork had been
designed in Photoshop, which gave it a stiff look.
We changed a lot of that by hand.

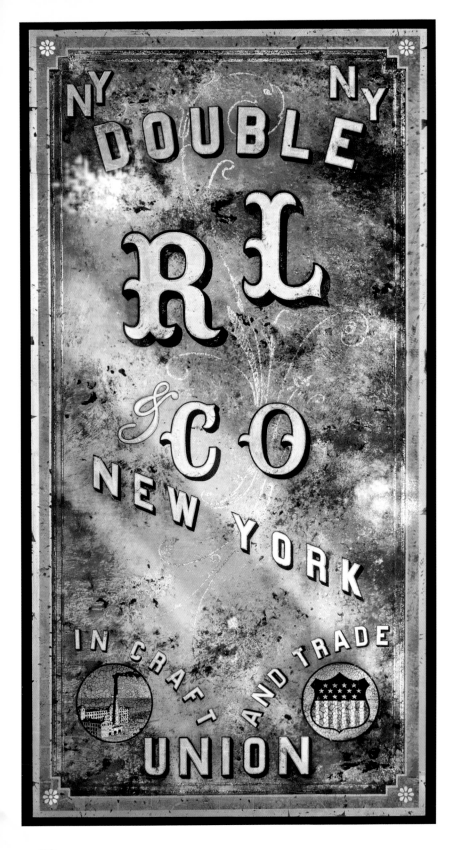

NY NY
DOUBLE
RL
& CO
NEW YORK
IN CRAFT AND TRADE
UNION

Left and opposite:
Mirrors created for a Ralph Lauren
store, New York City (collaboration
with designer Dikayl Rimmasch)

It's one thing
to see something old
and in beautiful,
pristine condition
and re-create it.
But it's another thing
to figure out how
it has worn itself away
and to replicate
that process.

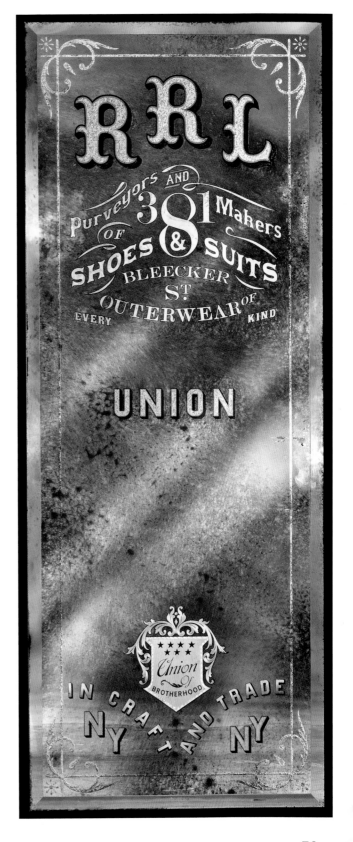

Sean Starr

> If you're looking at strip mall after strip mall, they've all got the same white rectangles with block letters. People have been conditioned by that uniformity.

IN THE 1980S MY DAD went into business doing custom painting, and he hired me to help. We would travel from town to town to paint for different car dealerships all over west Texas. We'd do these really elaborate custom paint jobs on brand-new trucks. Eventually, we started painting buses, airplanes, you name it. We started getting requests to add company names and lettering to our designs. My dad didn't want to mess with lettering. He said, "If you want to do it, learn it."

A pivotal moment in my sign painting story is when I was working with my dad painting cars on the south side of San Antonio at a little, crappy used car lot. This old Mexican guy showed up on a bicycle with his sign kit in the basket. He started doing lettering on the window of the dealership. I was totally in awe. My dad was getting pissed off because I was supposed to be working, but I just freaked out on this guy. It was the coolest thing I'd ever seen.

When you get the sign-painting bug, it's not about the money. If it was, you could expand in the right market and have twenty people working for you, but you wouldn't have the enjoyable aspect of taking time on projects. If you're in a high-production shop, which I worked in on the digital and vinyl side years ago, it's just miserable. It's like a sweatshop. You don't have the latitude for creativity because you're being told, "Okay, we need three hundred of these, two hundred of these, by this deadline." Who cares about the money?

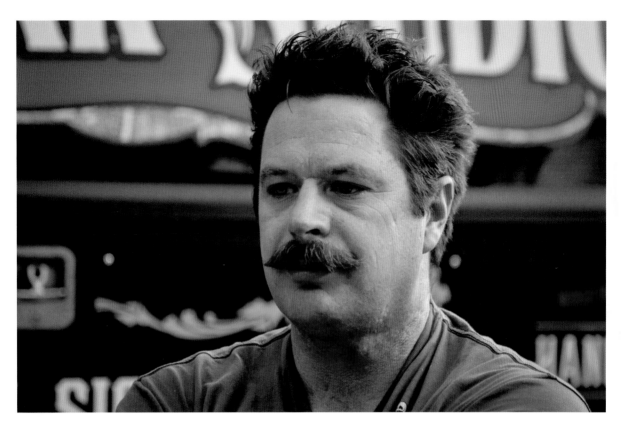

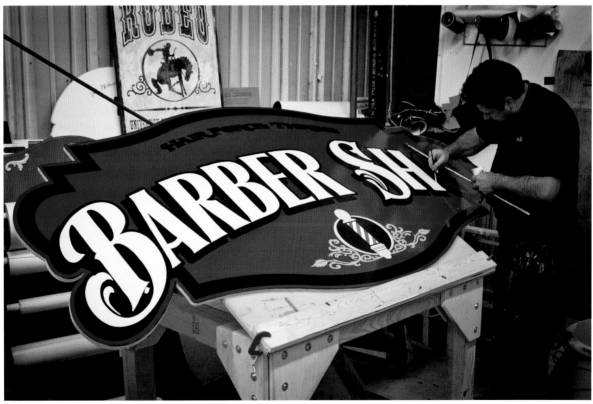

If the guy who's been
working at some job that
he hates moves on and opens
that coffee shop or store
he has always wanted to own,
that will change the
landscape of America.

A lot of business owners have lost sight of the passion that got them started and made them successful in the first place. But we're seeing it come back. Some of my customers were successful stock traders who got fed up with the system and the rat race, and decided to follow their dreams. Now they're looking at every aspect of their new business and saying, "Okay, what excites me?"

I think that's what people have been missing. That's why when you go to cities like San Francisco and you walk around neighborhoods, you're drawn to those places and you think, "That's a cool coffee shop." What made you think it's a cool coffee shop? The sign in the window creates an atmosphere that pulls you in. But if you're looking at strip mall after strip mall, they've all got the same white rectangles with block letters. People have been conditioned by that uniformity. When corporate America started taking over and steamrolling everything, we became more and more disconnected. People are starting to rebuild those neighborhoods. If the guy who's been working at some job that he hates moves on and opens that coffee shop or store he has always wanted to own, that will change the landscape of America.

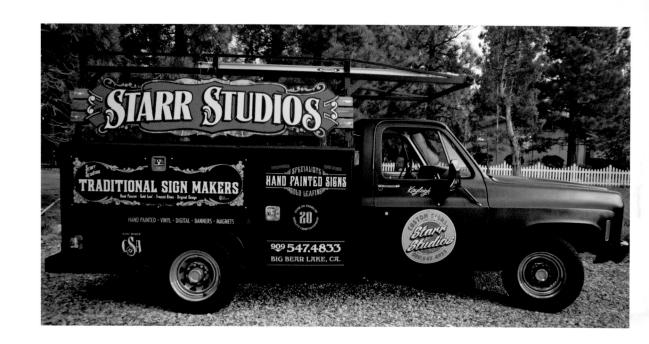

Caitlyn Galloway

I've always been interested in my own handwriting and how it's changed as I've grown.

WHEN I WAS IN ART SCHOOL, I was a painter. For whatever reason, when I graduated I put down my paintbrush for a number of years. When I first moved to San Francisco, I was determined to find work using my hands. I was hopeful about piecing together a living doing inspiring and creative things. I didn't know what that would look like until I was walking down a street in my neighborhood and saw some people installing a sign. I went up and asked them who painted it, and they said this great shop, New Bohemia Signs. I was super excited, so I holed myself up for the weekend and put together this really funny portfolio. It's embarrassing to think about that work now.

My other work outside of sign painting is as a gardener / farmer. I'm naturally drawn toward hands-on activities that are meditative, that I can be invested in and then have this amazing final product. I get in a similar headspace when I'm tending to the soil or focusing on making a letter look a certain way. I'm slowly, carefully doing something for a long time. What feels so nice is to focus on one small part, then step back and see the whole garden or finished sign.

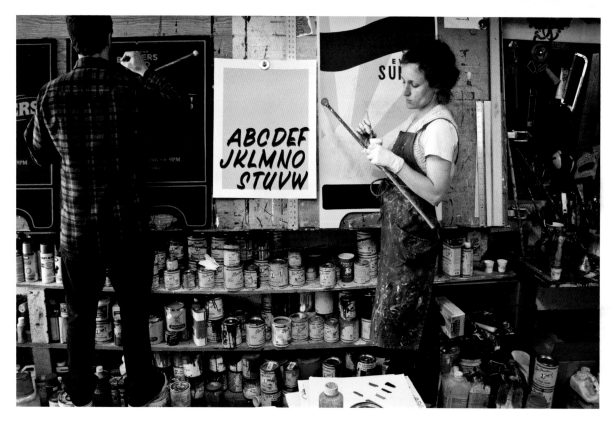

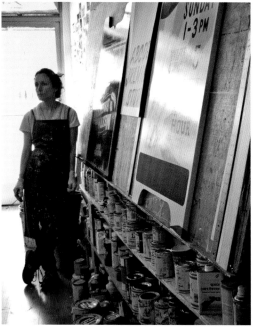

This page: Working at New Bohemia Signs

I didn't get into sign painting through graphic design or by liking typography. I've always been interested in my own handwriting and how it's changed as I've grown. I can remember when I was eight or nine thinking I'm going to make my *E*'s this way or my *S*'s another way. So, the idea of painting signs appealed to me. I wasn't thinking about this at the time, but my interest in sign painting is a reaction to feeling bored with the way things look. Signs are all around us, but I tend to not like 99 percent of them because everyone has computers and anyone can whip together a sign. It's appealing to try to contribute a more human element; I like the idea of my hand creating something.

When I look through books with old photographs of towns, what strikes me is the old signage. It has nothing to do with what it says or even the sign as a whole, it's just that each *O* isn't exactly the same. You rarely see that personality in a sign now.

SIGN PAINTERS

MAKE A RIGHT

EASTWARD

DUE WEST

LOOK FOR THE SIGNS

Mike Meyer

**Concentrate
and paint the sign
the best that
you can. There's
enough work
for everybody.**

MY DAD OWNED a barbershop and painted signs on the side. This was in the small town of Mazeppa, Minnesota, where I grew up. I still live and work here today. When I was a kid he painted one sign that I'll never forget. It taught me what a sign can accomplish. Our road was three blocks from Main Street. It was a gravel road and never maintained properly. My dad put up a sign that read, THIS STREET MAINTAINED? BY CITY OF MAZEPPA. The mayor came into the barbershop one day and said, "George, you've got to take that sign down." My dad just ignored him, so the mayor repeated, "George. I mean it. Take the sign down." My dad looked at him and told him, "Fix the damn road and I'll take the sign down." So the guys came from the city and filled the potholes, and he took the sign down.

There was another defining moment for me when I was in eighth grade. My dad and I were putting lettering down on the Mazeppa Town Hall. I was painting the part that read, TOWN HALL, and the *W* looked like a *V* and should have been wider. I remember him saying, "That's wrong. Don't do it that way." I walked away thinking, "Well, I'm not going to do this ever again. This sucks." Then I went home and I realized why he said that. I thought, I'm going to go back and fix it. I've never forgotten that.

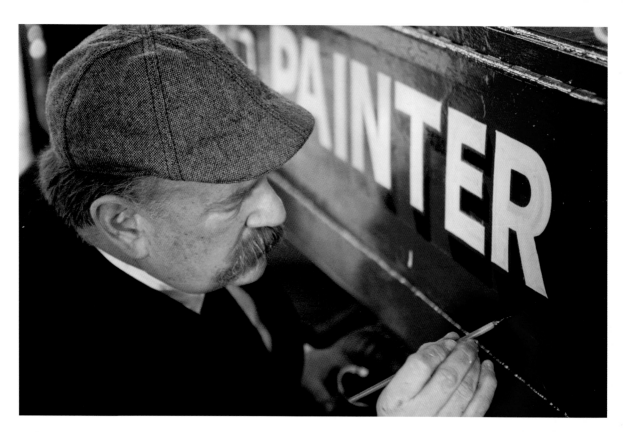

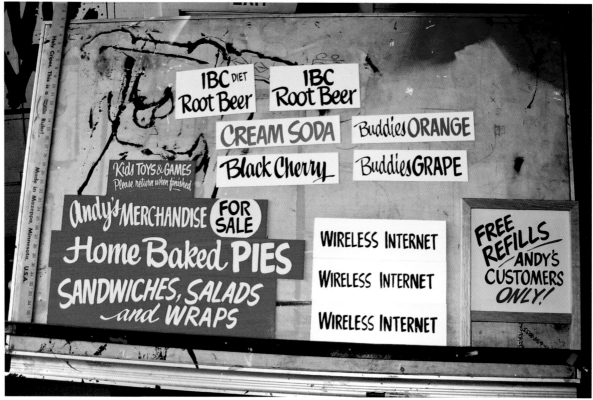

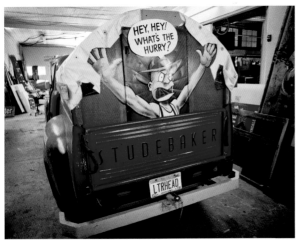

When I was in sign school, students had to learn everything. Then you figured out what was comfortable for you. For example, I don't use a maulstick (a common sign-painting tool that looks like a long stick with a ball on the end) to support my hand. I've always used the pinky-down technique, which gives me more control and doesn't block my view as much when I paint. One of the things I really like about sign painting is how everything is done out of survival and ingenuity. If I need to draw a circle and I don't have a fancy compass, I'll use a can for an outline. Sometimes the simplest objects around you are all that you need to get a job done.

Somebody told me a long time ago to think about myself 99 percent of the time and the competition 1 percent of the time. If you're always thinking about the competition then you're going to be thrown off your game—just like in sports. Concentrate and paint the sign best that you can. There's enough work for everybody.

I went to school in Northern Minnesota at the Detroit Lakes Vocational and Technical School, which had a sign-lettering and design program. I think it closed down three or four years ago. They were trying to keep up with technology. They should've had just one computer and kept teaching students how to letter by hand. Learning is boring, but once you get those basic strokes down you just start doing it, and when you finally paint a letter, it's heaven.

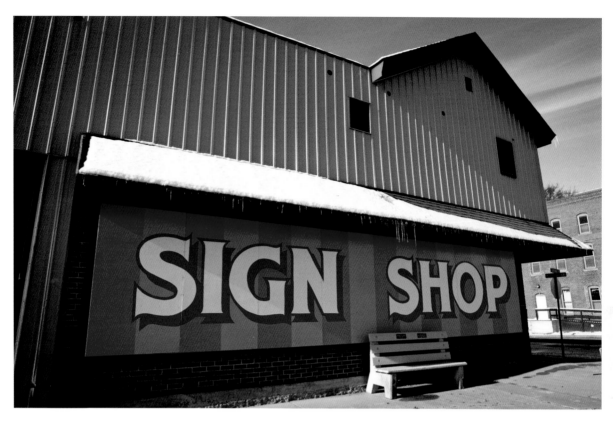

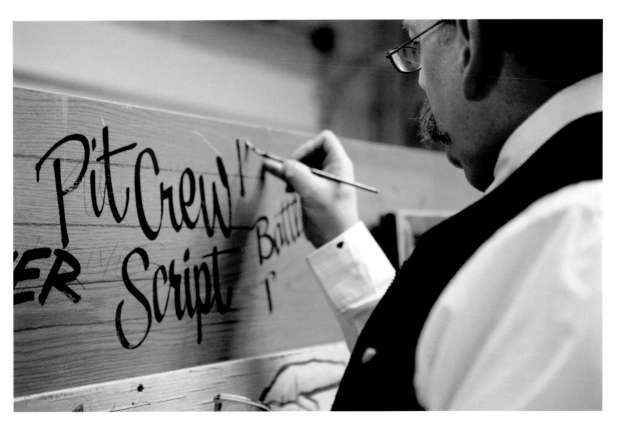

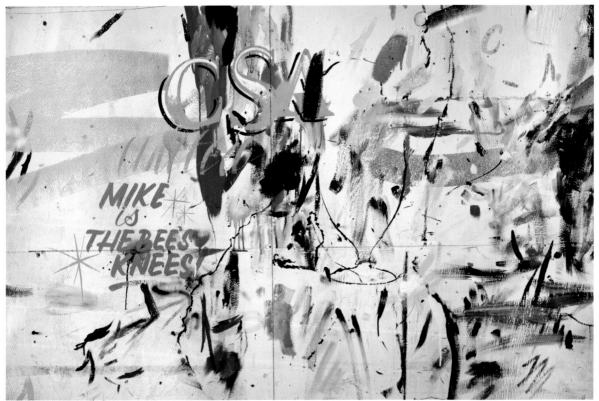

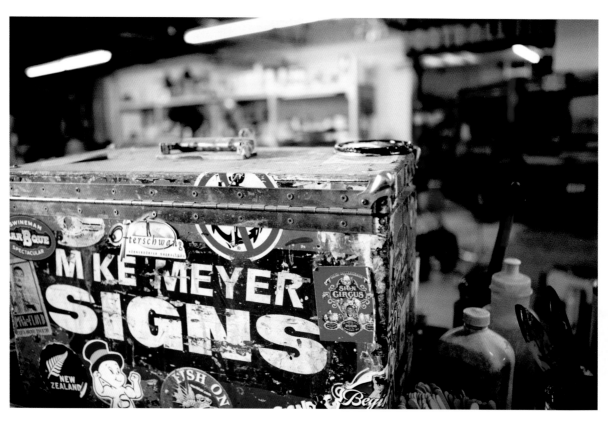

John Downer

I CAME TO IOWA IN 1973 to attend graduate school in painting at the University of Iowa. I'd finished my sign-painting apprenticeship in Des Moines prior to coming to Iowa City. I have been an Iowa City resident since 1973—except for a five-year hiatus in San Francisco when I pursued a type-design commission. That's where I learned how to create typefaces on a Macintosh.

Drawing and spacing are one in the same job. I design type and digitized characters that compose a larger character set. I never gave up sign painting or lost my appreciation for brush-lettered forms. However, I am thankful that the Macintosh came along, as well as Fontographer software, because both enabled me to increase my production. I could do six iterations of a single letter in an hour, whereas before it would take me a day with pencil on paper.

> **You don't outline a sign painter's letter and then fill it in with a Q-tip—that isn't really sign painting. You use the appropriate size brush and do it in three strokes. Who can do that? My computer can't.**

People are often confused by terms, and they misappropriate terminology. For example, I have been asked what font I use when I sign my name. A font is a reference to a collection of characters in a particular style and weight. A typeface can include many different fonts. Roman is one font, italic is another, bold is a third, and bold italic is a fourth.

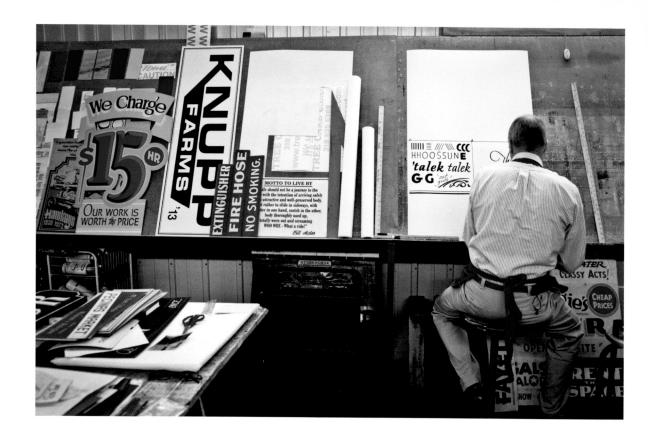

Reverse glass gilt sign with burnished outlines, tinted varnish matte centers, multicolored close shade, and roller-blended background

Drawing and spacing are one in the same job.

Terminology in the type trade is slightly different from terminology in the printing trade. In the printing trade or even in graphic design, a shadow is what we call a shade in the sign trade. It's a common mistake for those who are in the graphic arts to refer to any shade as a drop shadow. A drop shadow is one particular kind of shade; it's a repetition of the letterform itself. It's as if the letterform is cut out of construction paper and then levitates off the surface and casts its exact image. A close shade makes the letter look as though it's raised from the background but without space in between the back of the letter and the background. To make a wedged shade the top of the letter is peeled away from the background, which casts a shadow, but the bottom of the letter is hinged. Those are the three principle types of shades.

Sign painters shade their letters to the lower left by default. The *E* is the most frequently used letter in the English language. In the sign trade, we use more capitals than we use lowercase, so the capital *E* is the most ubiquitous letter in traditional sign painting. You can shade that letter with four strokes if you shade to the lower left, but it takes eight if you shade to the lower right.

Those of us who have a foot in the digital world can quickly see the advantages of using computers. Everybody wants quick, simple, and cheap, but painting a sign still takes time. Today you don't have to be able to draw and execute a good letter. People think that if it's readable, that's sufficient. When young people call themselves sign painters, technically they're right: they are using paint, and they are making signs. But when the older guys say the young people aren't real sign painters, they mean something different. They are referring to the method and the final appearance. You don't outline a sign painter's letter and then fill it in with a Q-tip—that isn't really sign painting. You use the appropriate size brush and do it in three strokes. Who can do that? My computer can't.

Show card for Seattle premiere of the movie *Helvetica*

Above and overleaf: Grocery store signs on butcher paper

DOLE
JUICE
BLENDS
Ass't'd.
$169
64 oz.

Shasta
COLA
$199
12-PK CANS

SWEET
ONIONS
FRESH
from Hermiston
39¢
LB.

CROSS RIB

SHOULDER ROAST

USDA choice

$1 99

LB.

Ernié Gosnell

**I could go anywhere
I wanted to go and do whatever
I wanted to do.**

I WAS BORN AND RAISED in Atlanta. Back in the day, a lot of tattooers were also sign painters because the wintertimes were slow. They would go to Florida with the carnies and paint corn dog stands, merry-go-rounds, that sort of thing. I've been hanging around a tattoo shop since I was twelve. I met this lady wrestler who was a really good sign painter. She tattooed a little bit on the side, but she was a great sign painter and she taught me a whole lot.

I worked at a place in Atlanta called Darnell Advertising back in the '60s. Dusty Beran owned the company. Great dude, he was like a daddy to me. I was young, running crazy then, mainly working as a show card writer, painting up quick and temporary advertisements for all the clubs and cabarets. I would paint show cards for them every week. Hell, I did Burt Reynolds's restaurant Burt's Place at the Omni International Hotel in Atlanta. In the '70s I remember Dusty telling me, "One of these days all you prima donna motherfuckers, they're gonna make something that's going to put you all out of business." We just had so much work at the time. And that's what happened with vinyl letters.

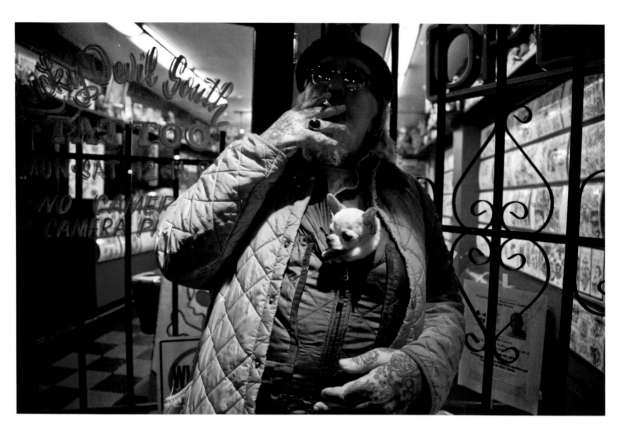

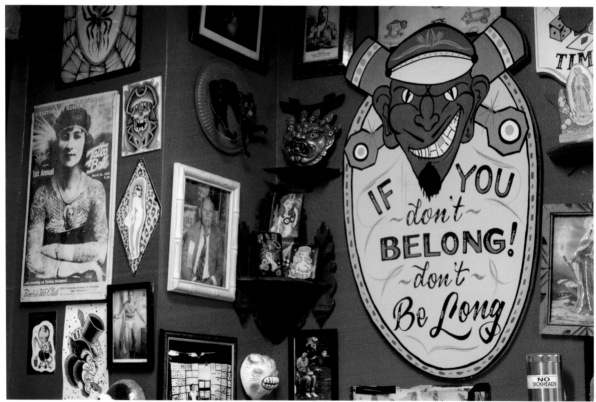

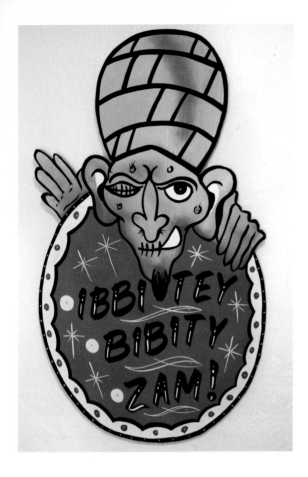

The world has totally changed, and I'm glad I'm on the backside, you know? I got the good end of the stick. Just seeing young kids now, they're the ones who are going to have it tough.

We did all the signs for Home Depot when the store first opened. They gave us a warehouse and furnished all the supplies. There were these huge vinyl signs, and we had to paint them all with vinyl ink. I would cut in the letters with fitches, brushes made for that type of work, and my buddy Allen would roll in the centers. After we finished signs for about ten stores they thought we were making too much money. So they offered us jobs as the heads of the new art department. They were going to give us all these shares in Home Depot. I said, "No, I ain't got time." I had too many cars to buy, too many motorcycles to build, too many drugs to do. All sign painters were drunk and crazy dudes back then. I lost a lot of old mentors of mine to alcohol.

I was a hippie. Nobody was going to hire me with hair down to my waist, riding in on a motorcycle. Sign painting was the only thing I could do. I could make a living and not have to deal with the man. I could just get on my motorcycle and ride. I'd have paint in one saddlebag, brushes in the other, and a pair of jeans rolled up on the back seat. I could go anywhere I wanted to go and do whatever I wanted to do.

I never thought I would quit painting signs. I still have my original sign kit. Hell, I've got brushes I've had for forty years that I still use. I still paint all types of silly shit around the tattoo shop. When the vinyl letters started in the '80s, I didn't know how big they would get. For a time I still got calls to do piecework at the sign shops, but the vinyl letters took over. I never thought a computer would come along and punch out these vinyl letters. The computer can't do as pretty of a job as the hand, but it still put a lot of people out of business. The world has totally changed, and I'm glad I'm on the backside, you know? I got the good end of the stick. Just seeing young kids now, they're the ones who are going to have it tough.

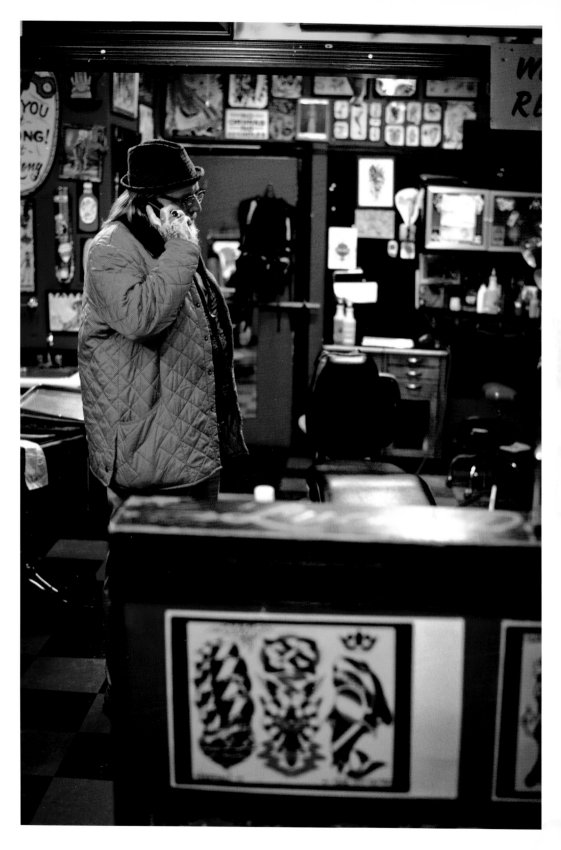

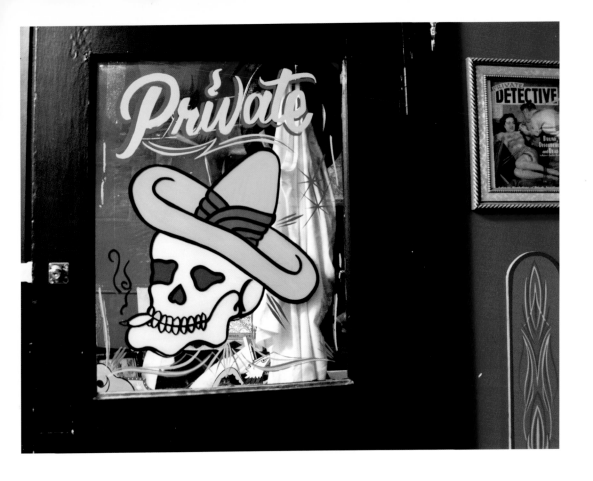

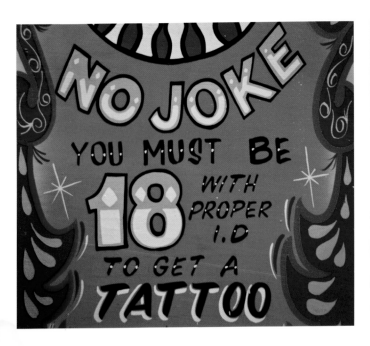

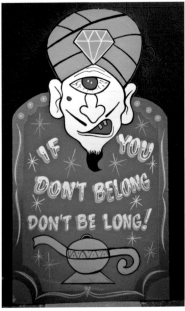

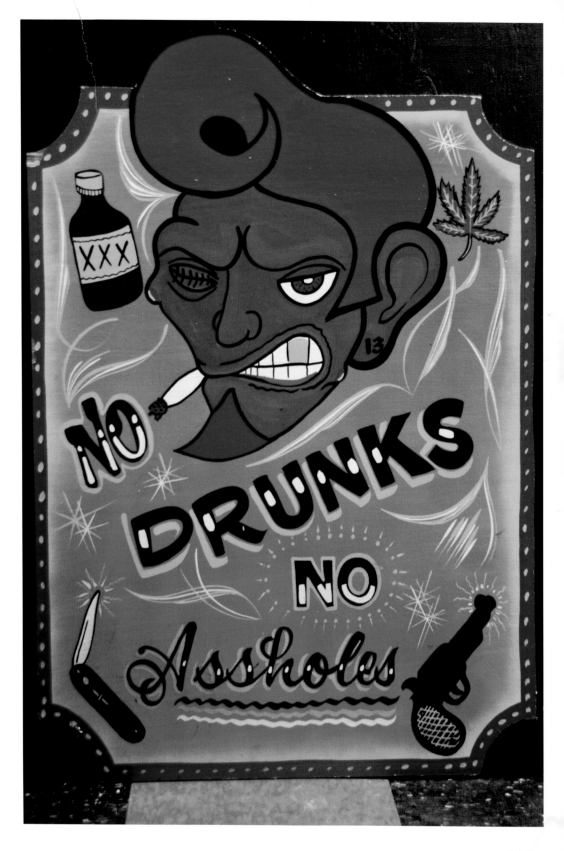

Jeff Canham

One of the mantras
I learned while working
at New Bohemia is,
"always aspire
to greater speed."

I WENT TO SCHOOL FOR graphic design at the University of Oregon, where I got my bachelor of fine arts, with an emphasis on typography. Then I worked at a magazine for five and a half years, so I was trained in print. I also did some fine art stuff on my own, and a lot of that was letter-based. When I moved to San Francisco, a friend of mine was opening up a new store and needed a sign made, so he went to New Bohemia Signs, and I went with him. I loved what they were doing and asked how I could get involved. They told me to apply for an apprenticeship, and that's how it started. A couple of months later it was a part-time job, and the next thing I know I'd been there for five years. One of the mantras I learned while working at New Bohemia is, "always aspire to greater speed." I stopped working there, but I'm still involved in the shop.

At the time I went to school they were teaching all the traditional means of graphic design, as well as how to do everything on the computer. I was lucky in that sense. That's still apparent in the work I do now because I'm interested in combining old techniques with new ones. Some jobs I've done using only sign-painting processes. For example, I designed and painted a bunch of signs for an illustration in *GOOD* magazine. I assembled them and took a picture, and it ran in the magazine and on its website.

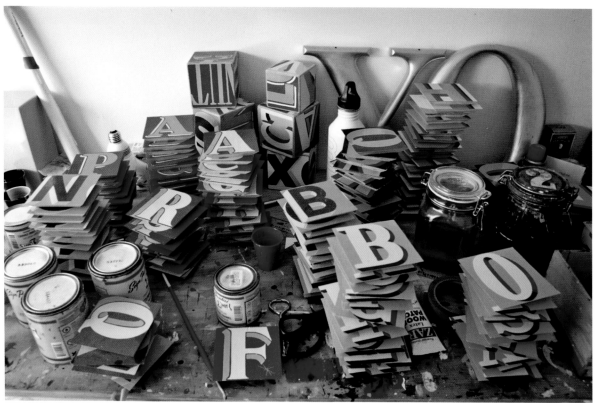

People are definitely intrigued by the fact that I have a sign-painting background and that's part of the reason that my work has been successful. I think that's an interesting discussion. There's a fine line between art and advertising. I don't know where you draw the line between one and the other. For my career I've been able to straddle those two worlds, so I'm comfortable in both realms. Just about everything I do has some kind of combination of hand painted and digitally rendered. I'm still a graphic designer and that work pays the bills, so I'm chained to the computer way more than I'd like to be.

I came to love sign painting by doing it. I wasn't necessarily hell-bent on doing everything by hand. I was bored with the computer, and it was a rejection of that technology. So much of my job was just sitting, scanning, and printing. I guess all along I've been trying to incorporate things that were hand done because they would be unique and wouldn't look like what everyone else was doing. I was just trying to come up with a way to personalize everything.

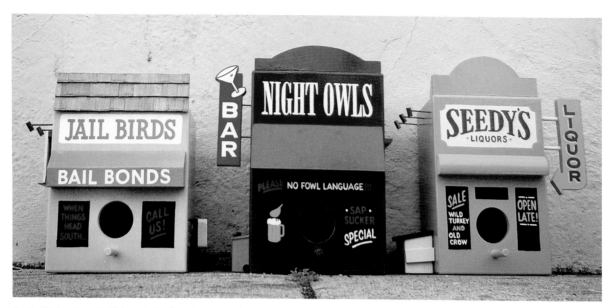

For the Birds, avian establishments for the urban bird, 2010

Damon Styer

One of my resolutions was to commit to some kind of creative work ethic.

I EARNED A DEGREE IN PAINTING from the San Francisco Art Institute. When I graduated, I went to work on the stock exchange and eventually became a broker. I figured I'd do it for a year, and then six months into it I couldn't stand it anymore, so I quit. I went to Southeast Asia and traveled for about half a year trying to figure out what I wanted to do with my life. One of my resolutions was to commit to some kind of creative work ethic.

New Bohemia Signs was a few blocks from my house in San Francisco. I'd been there about a year before and asked about apprenticeships, but there wasn't anything available. This time I walked in and they said, "Come in tomorrow, we'll pay you seven dollars an hour." I was shocked that I was even going to get paid. That was in June of 1999 and by the following December, I was the proprietor.

Work is seasonal in San Francisco. Winters are dead, and by summertime we're gangbusters. For the longest time, I was running the shop alone. In 2007, I was looking for help because it was wearing me out. I hired my longtime friend Scott Thiessen, who now handles all the business management. I don't have a promotional bone in my body. I'm so much happier coming in knowing that I'll be drawing, painting, or designing things.

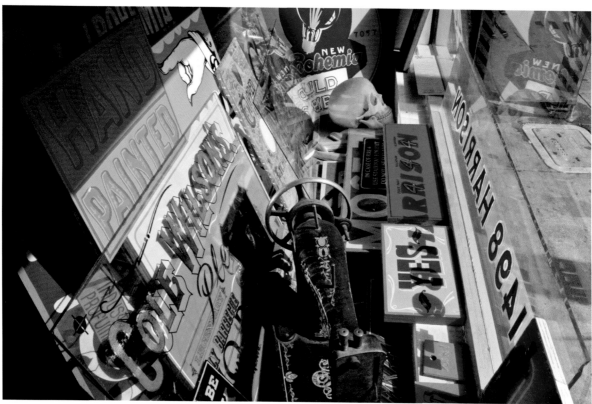

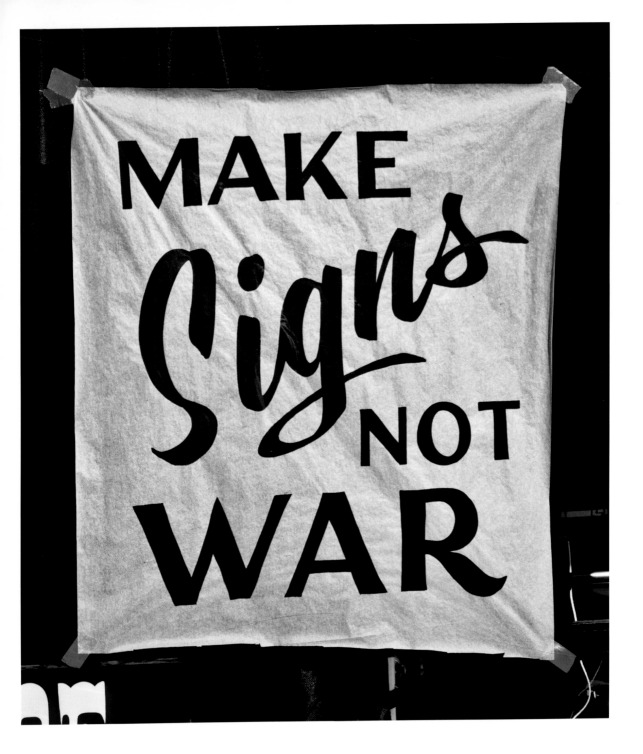

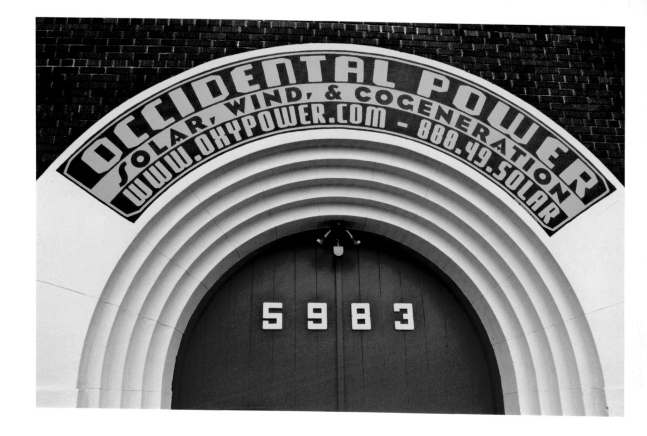

I'm not sure why it occurs to people to call us if they just want a sign, quick and cheap. But there is a segment of the population that's looking for something hand painted. Whether or not the design has any sort of painterly quality to it seems beside the point. They want the sign to be a certain way, and they're delighted to have found somebody who is still hand painting.

I don't know how a new generation of sign painters is supposed to make it. It's not just about good design and nice hand lettering. It's about being able to do it quickly and efficiently so that you can get paid enough to keep doing it. Practice is a part of it, but so is having good supplies, the right brushes, a smooth-enough board, and paint that's going to coat in one shot.

Using technology can be a slippery slope.

Using technology can be a slippery slope. The challenge is to continue drawing letters by hand rather than just settling on all the fonts that you can pull off the Internet to generate whatever people want. Because of that, I ask people who work here to come in for half an hour a day and practice brush lettering until they develop a sense of how you twist the brush to get an *O*. They develop their own habits, their own way of creating a letter, that becomes how they do it for the rest of their lives.

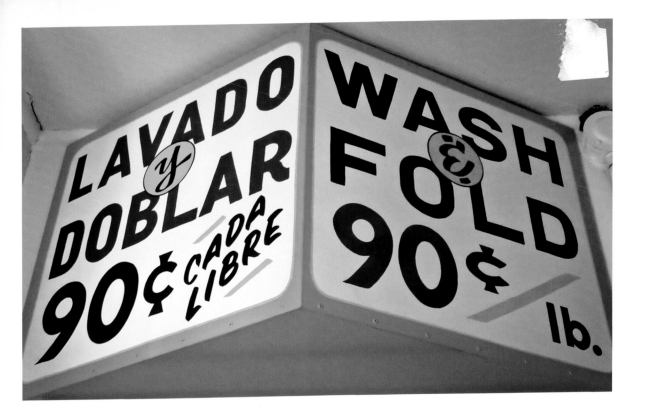

Practice is a part of it, but so is having good
supplies, the right brushes, a smooth-enough board,
and paint that's going to coat in one shot.

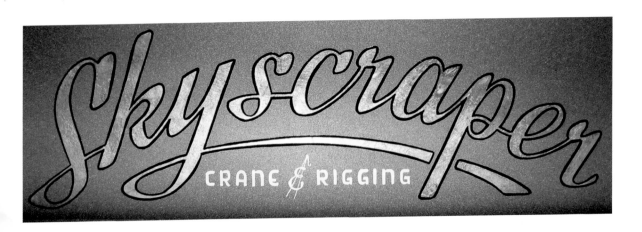

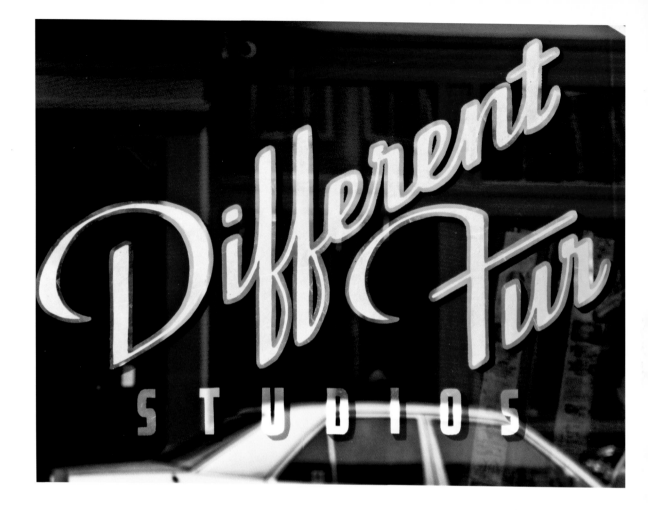

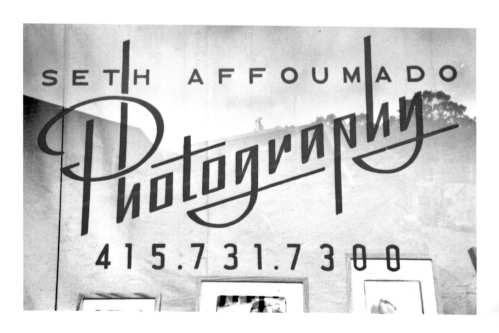

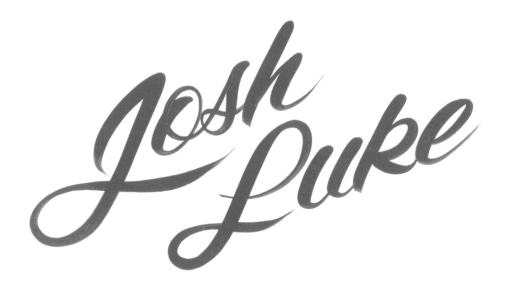

—

I see sign painting as a way to positively affect the visual landscape of my city.

—

I WAS FIRST DRAWN to sign painting out of a love for lettering. As a teenager, I was interested in the graffiti scene in the East Bay and San Francisco. I spent a lot of my time sketching and painting letters. I was always intrigued with the apprenticeship system of the Renaissance, how young painters studied under a master to learn a trade. I was offered an apprenticeship at New Bohemia Signs. This enabled me to participate in that system while indulging in my lifelong love for lettering.

Sign painting is experiencing a comeback. I've been a sign painter for less than ten years, but in the last two or three years I've noticed a much higher demand for hand-painted signs. I see sign painting as a way to positively affect the visual landscape of my city. As a newcomer to Boston, it's great to know that the city has recently invested in beautifying its streets and storefronts. I hope that an interest in hand-painted signage will not only help the city develop aesthetically but also pay tribute to its rich architectural history and sign-making roots.

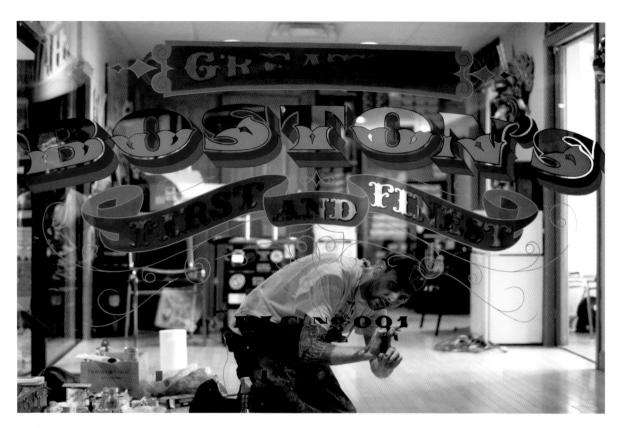

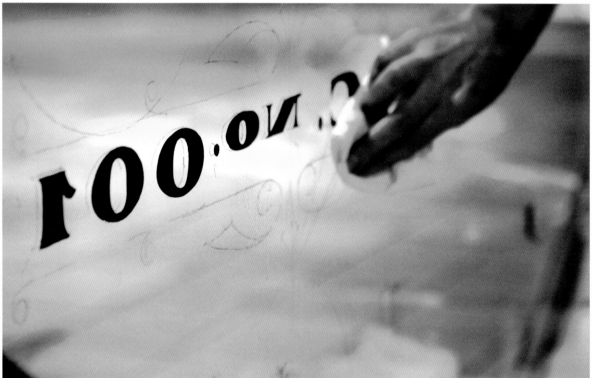

Top and bottom: Chameleon Tattoo & Body Piercing shop, Boston, MA, 2011

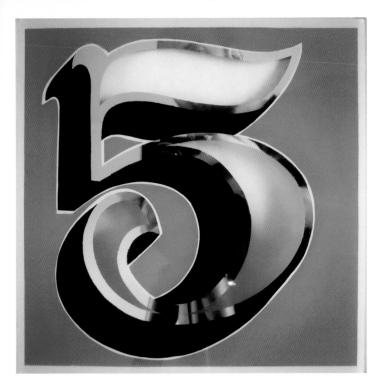

When I first started working with real gold, it was at least half the price of what it is right now. It does make the sign a lot more expensive. If you really want to invest in a sign and you want it to stand out, gilding with real gold leaf definitely has its advantages. I don't know if it's gluttonous to have gold on your windows, but I'm very aware of how much I waste because every time I'm laying down gold it's like another two dollars, which is a lot for me these days. I am finding that businesses don't know that gold is an option; they think it's something from the past and there's no one left to do it. Yes, it's more expensive, but it's worth it in the long run; it represents your business.

I started the Pre-Vinylite Society with the hope of connecting some of the younger sign painters I was meeting through various social media sites. I wanted to have a space for the up-and-comers to show off their work, get tips, get inspired, and learn history, etc. Through the Pre-Vinylite Facebook page I invite people to post pictures of their work and post signs that they're excited about. It's very informal; there's no official membership. To become a member at this point you only need to participate in the dialogue on the Facebook page and post your work.

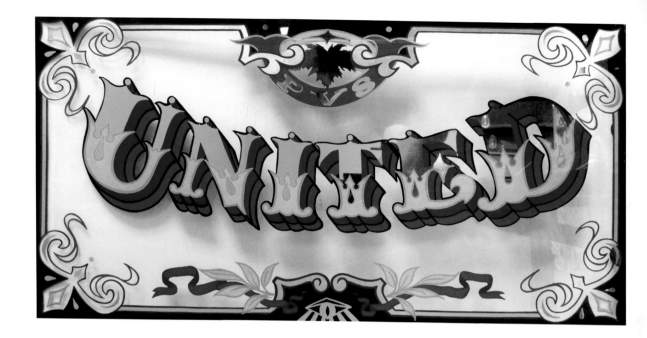

As a younger generation of business
owners begins to invest in hand-
painted signs, it makes the older generation
remember and appreciate a time when
all signs were done by hand.

The name of the group is inspired by the Pre-Raphaelite Brotherhood, a group of young English artists in the nineteenth century who were tired of the contemporary trend in art that venerated and imitated Raphael's classical model. They held that the kind of rote, mechanistic replication permeating the paintings of their day corrupted art and made it devoid of emotion and humanity. In a similar vein of rebellion, the Pre-Vinylite Society proposes to subvert the recent convention of lifeless vinyl signage as a digression from the time-honored institution and rich history of hand-painted signs.

Now that I live in Boston, I love being involved with local, young business owners. We're all working to make Boston a more artistic city. As a younger generation of business owners begins to invest in hand-painted signs, it makes the older generation remember and appreciate a time when all signs were done by hand. I don't think this resurgence is an isolated incident—it's part of a larger trend toward handmade processes. People generally seem to be moving away from mass-produced products; they want something with more warmth and humanity.

In 1840 there weren't
big advertising agencies
on Madison Avenue
designing logos
and creating campaigns
for these companies.
Sign painters
designed those logos.

SIGN PAINTING, as we know it here in America, is a good 150 years old. It all started when growers and manufacturers began to brand their products. Before that, if you needed flour, you went to the general store and the shop owner would have a barrel of flour and would fill up a canvas bag for you. Manufacturers realized that they had to market their products to show that their goods were better than the competition. That's when Gold Medal flour, Morton Salt, and other brands were introduced. In 1840 there weren't big advertising agencies on Madison Avenue designing logos and creating campaigns for these companies. Sign painters designed those logos.

We all start out lousy. For years I couldn't get a sign painter in the city of Toledo to show or tell me anything. It really was a closed fraternity. I was lousy and slow, and I couldn't do the really good jobs to get the good money. Then I met Burt Mayer. He knew more about sign painting than any living human. He was a grumpy, grouchy old guy—just like the ones you hear about. He was a tough taskmaster. On more than several occasions I wanted the satisfaction of busting him one.

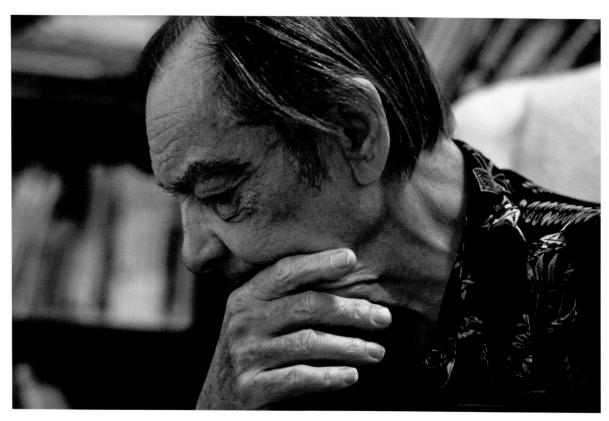

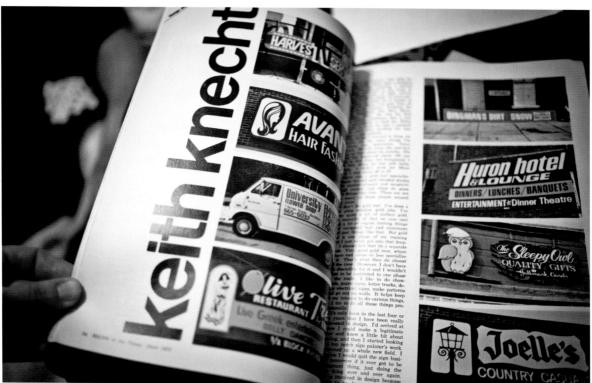

Above: Cover story from *Signs of the Times* magazine, June 1975

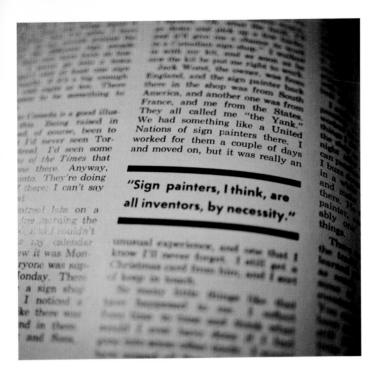

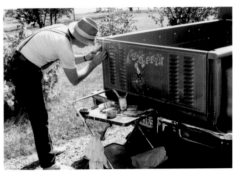

He would make me go back to the shop at night after work and practice. He'd say, "All right, tonight I want you to work on your *O*'s." And I'd do row after row of *O*'s. The next night he would stop in and take a look. Out of all the *O*'s, he'd pick out the worst one and say, "That's the worst goddamn *O* I've ever seen in my life." Then he'd walk out. That happened too many times to be fun.

But I was learning, and I knew I had to pay the price. I'd bite my tongue and go along with it. He finally said, "Keith, it's time for you to move on. Out of one hundred sign painters, only three or four become outstanding, and I think that you can be one of those three or four." He told me that if I find out that they're doing good work in St. Louis, go to St. Louis. If I find out they're doing good work in Atlanta, go there.

When I left he said that if I ran into a job that I couldn't handle to call him, and he'd help me out. So I'd call him from Atlanta, Tucson, or someplace like that, and I'd say, "Burt, I've got a job to do on Monday and I've never done one like this before." He'd ask, "All right, what is it?" So I'd tell him. He'd give me the whole rundown and say, "Okay, if you run into any more problems, just give me a call." I had him with me until 1975. It's hard for me to say this, but I loved the guy. I really loved the guy.

There's nobody that I've met since who's given me what he gave me. He gave me everything, and signs gave me everything: my feelings of self-worth, my income, my roof, my food, my gas, my vehicles, my romance. He fed my romance for signs, oh God, and I loved it.

Nick Barber

I had the reputation
of being real slow at first.
Then I got married
and Mama liked to shop,
so I got real quick.

I PAINT TEMPORARY WINDOW SIGNS all over Southern California. Basically, some guy starts up a business and he's not sure how long he's going to be open. Rather than spending ten or fifteen thousand dollars on an electric or sandblasted sign, he has me come out and put on hot colors that are going to look attractive for a year, and he just goes with that. From my understanding, the story of how temporary signs got started here in the late '60s is when some guy from New York drove cross-country and brought the technique with him. It evolved from there.

When painting traditional signs, you mix colors; there is an unlimited palette with which to work. With window splash you don't mix colors because they get muddy. You work with what the manufacturers make. There are five basic colors in my palette: Saturn yellow, yellow orange, blaze orange, rocket red, and Aurora pink. I never use pink without asking the customer first, because some people don't like it. And during the holidays or springtime, I'll tint the yellow and make some nice green.

The original watercolor temporary paint would fade in the sun after two weeks. Then this alkyd enamel came out that lasts a lot longer on the window. It's great, rain proof, and fade resistant. It's more expensive than watercolor paint, so a lot of people didn't go for it at first, but it's all I use now.

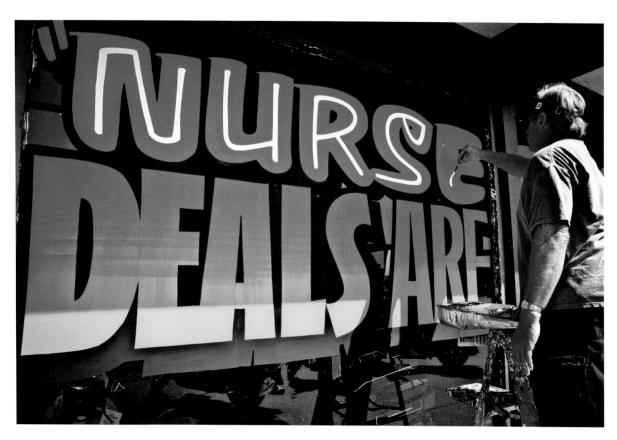

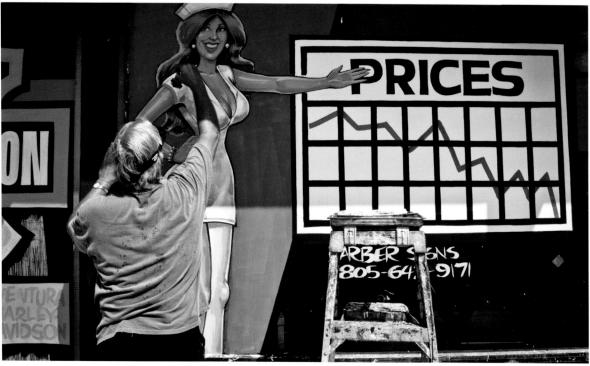

Top and bottom: Ventura Harley-Davidson dealership

There are five basic colors in my palette:
Saturn yellow, yellow orange, blaze orange, rocket red,
and Aurora pink. I never use pink without asking
the customer first, because some people don't like it.

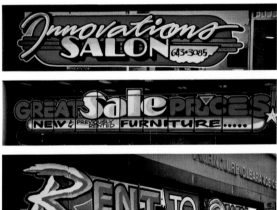

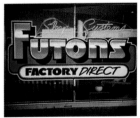

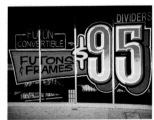

How to Paint Watercolor Window Splashes, a lettering manual published in 1994 by SignCraft Publishing Co., Inc

Opposite (top), above, and overleaf: Ventura Harley-Davidson dealership

I soap my paint to make it easier to scrape off. When the Windex hits the paint, it reacts with the soap, loosens it up, and makes it easier to remove. I always under-coat all of my work with white paint because the fluorescent colors don't have a lot of opacity on their own. I show up to the job location, crack my trunk, and lay everything out in white. I draw the horizon-tal lines for the main copy with a roller. I don't even use sticks anymore, just my muscle memory. I use my body as a tool; my arm will actually keep a fairly straight line. Then I start painting with the lighter colors and build it up from there.

I had the reputation of being real slow at first. Then I got married and Mama liked to shop, so I got real quick. I picked up *Mastering Layout*, by Mike Stevens—every sign painter's basic bible—and studied it all. I love mixing up the fonts.

I love contrasting loose fonts against structural fonts, thick against thin. Inspiration is everywhere if you're looking, and receptive. That's how I learn: I get inspired, take pictures, and study them. I don't want to copy what somebody else has done, but I take something, add my own touches, and make it my own.

I've been known to make a few mistakes on the job. One time I misspelled breakfast. The restaurant owner pointed it out, "brefast." It was like Tony Montana in *Scarface*, "I'll eat them for brefast." He wouldn't let me change it. "Leave it," he said, "it's a great conversation piece."

I've got one of the best jobs around—the change of scenery, the autonomy, the appreciation. At some point there's got to be a backlash against the computer cut, as-cheap-as-you-can-get-it work. There's got to be a renaissance of appreciation of hand-done stuff. Hand done has a heart; it's got a soul and it has life.

Bob Dewhurst

There was a time
when I could show up in
a town on a Greyhound
bus, sleep in a field,
and be painting a sign
the next day.

I PAINT EXCLUSIVELY with 1 Shot, which brought my lead level up to ultra toxic. It leveled off in the past fifteen years since they took the lead out. The paint is nothing like it was; you can feel the difference. A lot of the traditional paints have names based on what's in them: titanium white, cadmium yellow, and cobalt blue. If I see an older sign I brushed with lead paint, it still looks great.

I used to paint inside a trailer. I try to work outdoors now, because I finally got sick of the fumes. Some people used to come in and they'd start to vomit. I didn't smell anything. I don't wear a mask when I paint, but I did start wearing rubber gloves a few years ago, except when I'm doing fine lettering. Some people can deal with paint and some can't. Your body can only deal with so much in a day. I wish I'd worn a mask over the years, but there's nothing I can do about it now. It's life. It's a hazard. Had I known I was going to live this long I may have done things differently. A lot of it's a mental attitude: be happy with life, that's the best thing.

I first got interested in sign painting because I was locked up in a mental institution. There was this guy who escaped, and when they finally caught him everyone wanted to know what he'd been doing. "I went to San Francisco and made all this money as a sign painter," he told us. I thought, "Yeah, maybe if I escape I can go to San Francisco and paint signs, too."

Later on, I found myself doing ranch work in Northern California for two dollars an hour. Some guy there needed a sign. I just learned, I didn't even know about sign-painting brushes. I would've liked to have apprenticed with a shop, but I never did. I can't do the pinstriping and the fancy lettering, but I'm good at walls. I like doing big walls and creative signs, with carpentry and some pictorial.

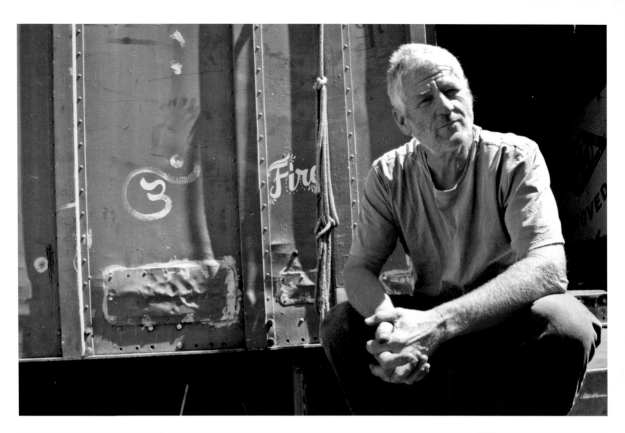

Being a sign painter,
I get to meet the sandwich
maker, the auto body
mechanic, the CEO
executive – I've connected
with the world through
the sign business.

I came here with nothing. I made my kit and thought I'd just walk down the streets in San Francisco, sell signs, and paint them on the spot. There was a time when I could show up in a town on a Greyhound bus, sleep in a field, and be painting a sign the next day. Someone would walk over and say, "When you're done, come by and do our shop."

I've always been fascinated with letters and colors. Letters are really cosmic things because the whole universe is made out of them. I never get tired of painting. It's like a meditation; I go into my own world. We are a consumer culture: we don't farm, we don't hunt. We buy stuff. I think signs and labeling—the packaging—is our real culture of art. We sign painters are really lucky because artists struggle and want to be recognized for their work. Hell, the streets of San Francisco are my art gallery. I can drive around and point— "I painted that, I painted that."

Part of what's gone wrong with the industry is that guys are getting older and quitting. I'm not interested in learning to use a computer. Now there's a whole new generation of project managers and executives and that's all they know. They don't even realize you can have a hand-painted wall sign. That's why you see these horrible plastic banners advertising quality companies. They make them look like fly-by-night businesses. It's up to me to talk to these people and say, "Look, here's what we can do for you." Being a sign painter, I get to meet the sandwich maker, the auto body mechanic, the CEO executive— I've connected with the world through the sign business.

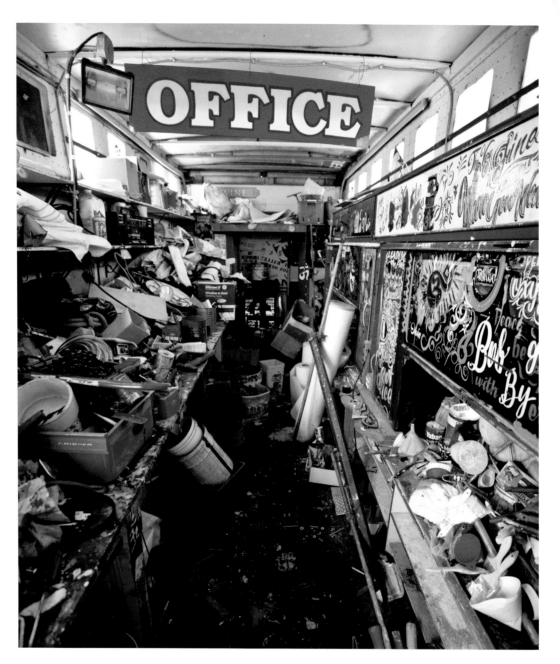

Phil Vandervaart

I'm adding to the urban cacophony and feel proud that I've affected the landscape.

THE PUBLIC PERCEPTION of what I do has always been a mystery to me. My work is too wildly diverse to say there's a trend toward anything. I tend to push everything to the comical because it's a sign, not fine art. It's meant to convey information and be attractive. Signs are decorative and informative at the same time. I'm adding to the urban cacophony and feel proud that I've affected the landscape. I'm not an architect, but my signs still impact the urban scenery as much as an architectural facade. All I want to do is put paint on a wall, so it's kind of a cheap thrill in a way. I don't make it over-important in my head; it's just a sign.

People come into sign painting from different places: house painting, art, calligraphy. I came from a drafting background. I'm fifty-eight, and when I started in my twenties I had access to a lot of the old-timers who are now gone. They were really brutal. Once, after watching me paint a sign, one of them said, "I want you to come back here." He walked me about thirty feet back and said, "Tell me why your sign looks like crap." At first I was offended, but then I really appreciated his feedback and I took it to heart.

When people want me to do a sign, they give me a concept of what they want. People used to be able to draw; they could at least make stick figures. And I'd be able to say, "Okay, I see your focus and mission." Over the past thirty years, the artwork from clients has disintegrated almost entirely. Computers took over people's decision-making ability.

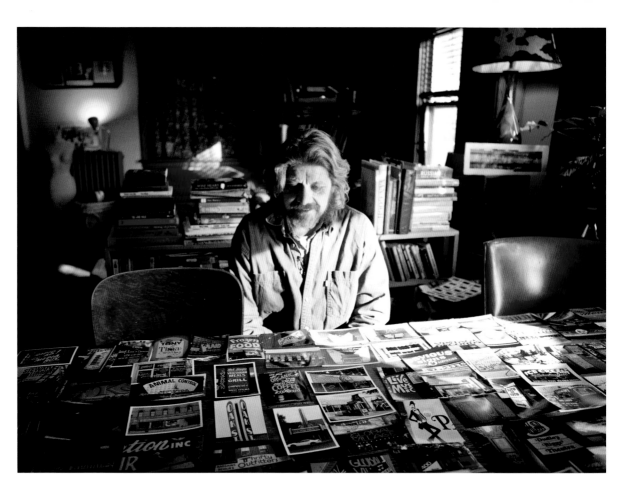

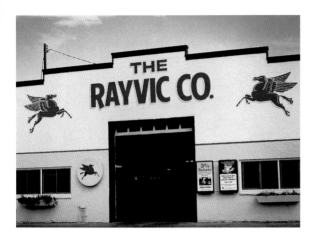

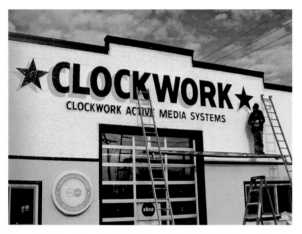

Top and bottom: Example of Vandervaart "killing" (painting over) a sign

There are some locations that I just paint over and over again. Through the years I've become obsessed with these buildings; I love painting on them.

1 Shot, Ronan—all the sign paints—used to have lead in them. They've had to replace or cut down on the amount, and there is a noticeable difference. They put lead in paint in the first place because it stays forever. Just imagine the thinners that you have to put in a can of paint to keep actual metals dissolved. Early in my career, I got sick a lot. I got lead poisoning, which feels like the worst flu-like symptoms. The trade is rough on your health. You have to be careful with these chemicals and watch your bad habits when using them.

I've always had people working with me, and I've been open with them. I feel it's my responsibility; I don't want to keep secrets. Sign painting is a public thing, and I couldn't possibly paint all the signs that need to be painted. I couldn't possibly replicate all these signs that are being done with vinyl lettering now. I just do one sign at a time, and I put all my heart and soul into it. My goal is for my clients' businesses to succeed; then, my signs stay up a long time. They paid me some money, and I want them to make some money. When signs do have to come down—a lot of them do even within the year I paint them—I've developed a habit of volunteering to be the one to paint it out. I want to kill my own sign. I don't want someone else to do it. There are some locations that I just paint over and over again. Through the years I've become obsessed with these buildings; I love painting on them.

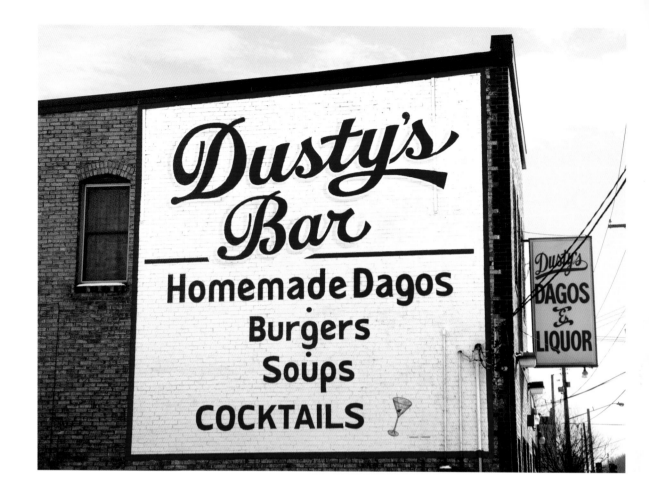

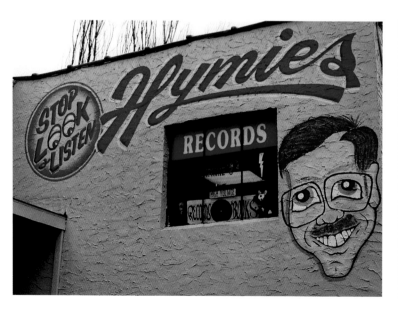

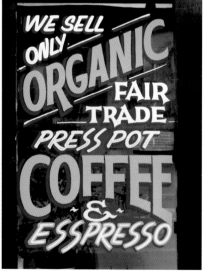

Forrest Wozniak

**Sign painting appealed
to my logical nature.
It's a way to pursue art
with a right and a wrong.**

I TOOK AN APPRENTICESHIP at the age of sixteen building Scandinavian contemporary furniture. Before that, I didn't even know how to use a tape measure. I got into the trades knowing that it would be an outlet to work with my hands because academics never worked out too well for me. My interest in sign painting emerged from that background. I'm not a natural talent, which is part of the reason why I stuck with sign painting. I'd rather fail at something that's challenging than succeed at something I know how to do.

After some time traveling and working, I came back home to Minneapolis, kept painting, and had a family. My relationship with Phil Vandervaart started over coffee and the *New York Times* years before we actually worked together. As kids growing up on the West Bank in Minneapolis, we took for granted how much of an influence Phil had on the urban landscape. I don't think any of us were fully aware that his signs were attached to a person. Now I've been working with Phil on and off for probably six to eight years.

I don't excel at lettering a perfect alphabet. If you were to tell me to just paint the alphabet I would struggle and hope that no one was watching. If you were to tell me to tuck-point a brick wall— remove the loose mortar between the bricks and repair the cracks—and then design a sign that could somehow ride cleanly over an unideal surface, that's a perfect job for me. I have an ability to understand buildings and the way they work.

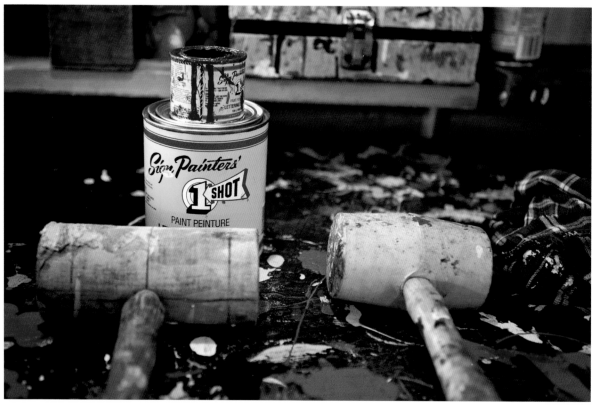

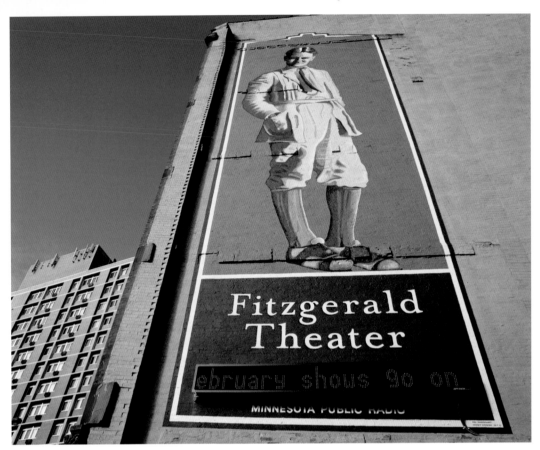

A collaboration with Phil Vandervaart celebrating the one hundredth year anniversary of the Fitzgerald Theater, St. Paul, MN, 2010

What I feel separates sign painting from art is that art is an exploration of one's self. Whether they are exploring their egos, emotions, or their pasts, artists are exploring themselves. There's no real failure in pursuing art. You have to do signs correctly; there's a correct format. It's similar to carpentry. If you need to cut something seventeen inches long, you have to cut it the right size. Sign painting appealed to my logical nature. It's a way to pursue art with a right and a wrong.

As a sign painter you are a deacon to society because you don't work for someone who is successful, you work for someone who hopes to be successful. They might have saved up for years, and this is hopefully their dreams coming true. My goal is for my work to look relatively timeless. If you looked at a black-and-white photo, you wouldn't be able to place the time period from which it came. There's an acceptance of how temporary everything is, but there's nothing temporary about sign painting.

Colossal Media

Paul Lindahl & Adrian Moeller

IN 2004 WE STARTED the company Colossal Media. We didn't have any clients, so we just put our own ad in an upcoming issue of *Mass Appeal*, Adrian's magazine. We pooled our money together and were able to convince a building owner to rent us his wall space for a month. That was our first portfolio piece that we shopped around to advertising agencies. Nobody in New York wanted to hand paint anything anymore. It was such an uphill battle to convince the advertising agencies to do something different and cool, to take a risk with us. We were this new company, and they just didn't believe we could pull it off.

After that first wall, Rock Star Games was our first big client: we painted twenty-five walls all over the five boroughs. That really put us on the map. We went out and acquired all those walls without knowing the legalities. We just kind of did it. It went off without a hitch, they loved it, and we learned along the way. At that point, it was just three of us doing everything; that was the start of the company.

Once we established that we could do a job and people started trusting us with projects, they realized that through hand paint they were able to attract a lot more attention. It draws crowds like you wouldn't believe. We have a lot of walls in neighborhoods at street level, and our painters spend half the day just talking to people. We get a lot of appreciation from the public. Now advertisers want the hand paint, they want to draw the public. That's what advertising is about. It's getting to that viewer and having people stop to look.

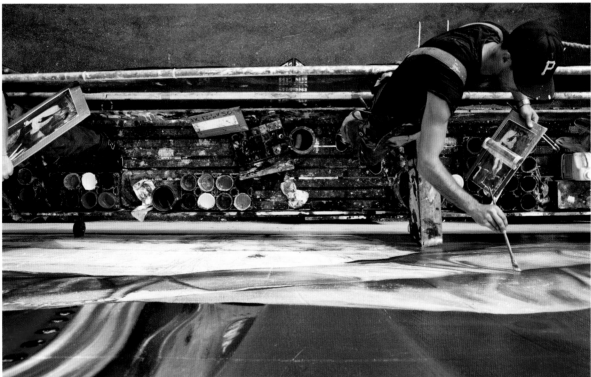

Top and bottom: Across the street from Yankee Stadium, Colossal Media's Sky High crew at work

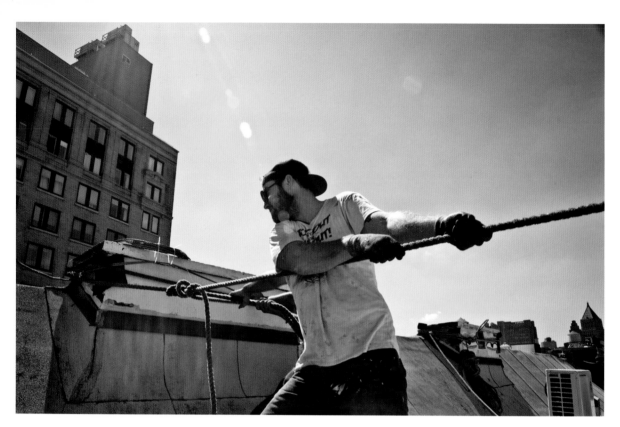

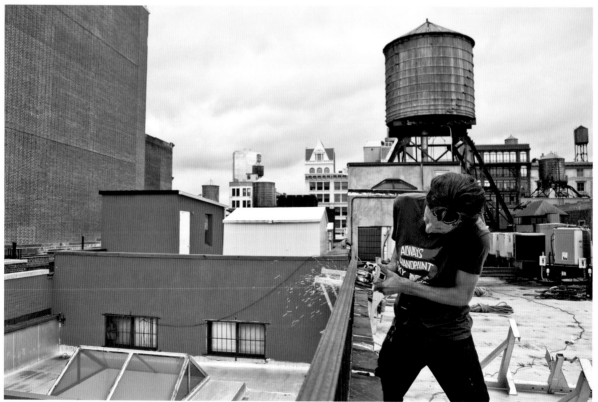

We have a lot of
walls in neighbor-
hoods at street level,
and our painters
spend half the day
just talking to people.
We get a lot of
appreciation from
the public.

A common misconception we hear a lot is, "I'm a good artist; I'll be good at painting walls." Or, "I'm a great painter; I'll be a good match." It's not the job that people think it is. It's very creative and you get to express your abilities, but it's also labor intensive and a hard place to work. Half of the time is spent carrying really heavy equipment, rigging, and prepping walls.

We have an apprenticeship program that throws people into the mix quickly and challenges them to see if they're a good fit. The apprenticeship lasts nine months, and it's broken up into two pieces. The first three-month period is spent entirely inside the shop. They learn how everything works, what kind of equipment we use, and its purpose. Once they make it through that, they go out with the crews and are put into very specific scenarios where they're watched really closely.

The spectrum of guys that we have working with us is pretty cool. We have a direct lineage back to the '70s. Some of these guys who work with us are sixty-five years old. They've been in the business since 1970. Other guys have been working here for two years. We don't hide any tricks here; we don't like the idea of one person knowing how to do something and keeping it a secret from another person. We want everybody working here to have access to the same information.

All the guys on the crews know each other well and know what to expect from one another. There's a real trust. It takes a long time to integrate somebody into that mix and have them feel at home. We can never have a painter walk onto a project if he doesn't understand and respect the entire process. If you put a painter on a rig and he doesn't know how it went up and something happens, you're out of luck. You're relying on the person right next to you for your safety. It can be a dangerous job if you don't know what you're doing.

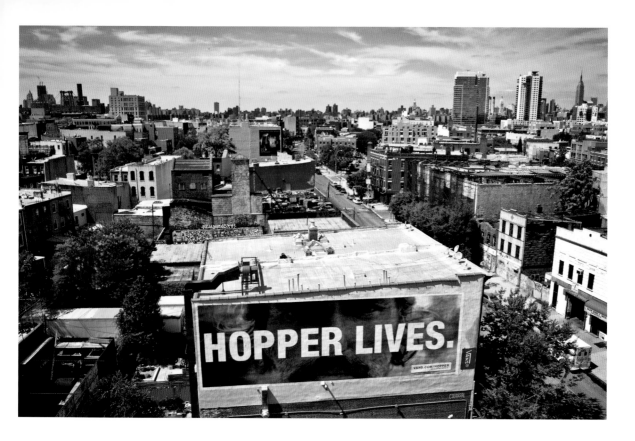

It's not an easy way to run a business or to make a living. It's really important for us to control the quality of the product and all the steps along the way. From the beginning we decided we're going to get our own locations, and we're not going to paint for other companies. And that's what we did, first in New York, and now in eighteen markets—we just started going neighborhood to neighborhood, city to city, and acquiring walls. The way that our company works or the reason why it works is because we control the inventory. We dictate that the facade or the wallscape is hand painted. We write up a contract between the building owner and us to lease that space for an extended period of time.

Pretty much everything that we're doing here has been done before; we aren't breaking new ground. At the same time, we're constantly trying to evolve as a company. We're taking this process that's been done the same way for a long time and improving upon it in any way that we can. It's hard competing with another product that's similar to yours and costs a fraction of the price. A company that sells vinyl can print and install twenty banners in the time that it takes us to paint one wall. People don't take a lot of time to do things anymore, and we're already losing the race by hand painting walls.

A cool part about this work is that you can never be the best painter. You can always grow and get better; the limitations boil down to you as a person. You walk up to a wall that's 300 feet tall and you don't say, "Holy shit." You say, "I can't wait until this thing has been covered in paint."

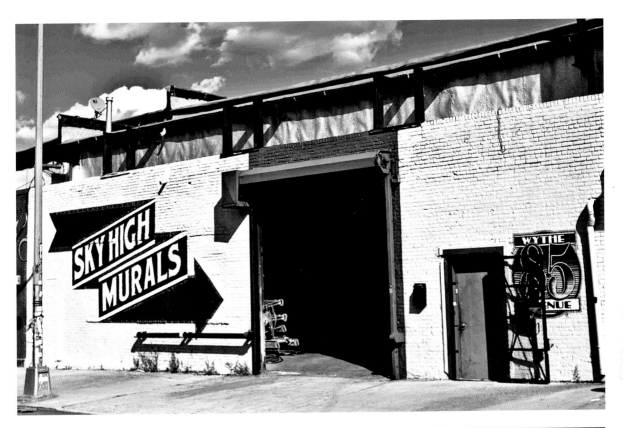

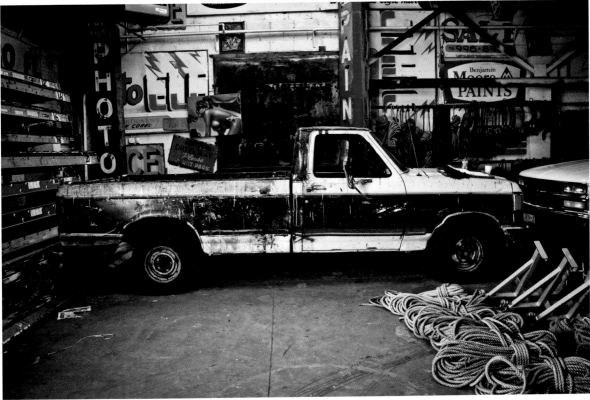

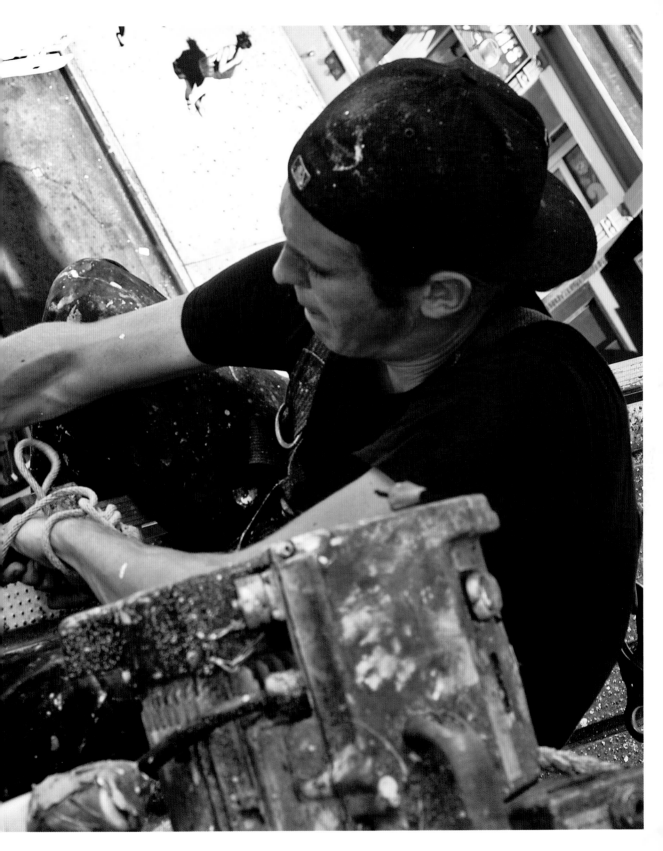

CONTRIBUTOR BIOGRAPHIES

Faythe Levine is a curator, author, collector, director, and maker of various things. Her wide range of interests propels her to constantly work on many projects at once. Levine's current focus, aside from *Sign Painters*, is curating Sky High Gallery and producing Art vs. Craft (both based in Milwaukee). She also continues to publish and exhibit her photographs, writing, and artwork internationally, in formal and renegade outlets. *Handmade Nation: The Rise of DIY, Art, Craft, and Design* was Levine's first film and book, published by Princeton Architectural Press in 2008.
www.faythelevine.com

Sam Macon is a Milwaukee-born, Chicago-based filmmaker, photographer, and writer. He received his BFA in film from the University of Wisconsin-Milwaukee, and directs music videos, commercials, short films, and documentaries. In addition to directing full time, Macon has taught and guest lectured on the subject of film and video at the Chicago Portfolio School, DePaul University, and Syracuse University.
www.sammacon.com

Born in 1937 in Omaha, Nebraska, **Ed Ruscha** moved to Oklahoma City in 1941 and to Los Angeles in 1956, to attend the Chouinard Art Institute. He had his first solo exhibition in 1963 at the Ferus Gallery in Los Angeles. He currently shows with the Gagosian Gallery in New York, Beverly Hills, and London.

Ruscha has been the subject of numerous museum retrospectives, the first of which took place in 1982 at the San Francisco Museum of Modern Art, before traveling to venues throughout the United States and Canada. Other major traveling retrospectives include those organized by the Centre Georges Pompidou, in Paris, in 1989 and the Hirshhorn Museum and Sculpture Garden, in Washington, DC, in 2000. In 2001, Ruscha was elected to the American Academy of Arts and Letters as a member of the Department of Art. The following year a major exhibition of Ruscha's entire body of work opened in Madrid at the Museo Nacional Centro de Arte Reina Sofía.

In 2004, the Whitney Museum of American Art, New York, organized two simultaneous exhibitions: *Ed Ruscha and Photography* and *Cotton Puffs, Q-tips®, Smoke and Mirrors: The Drawings of*

Ed Ruscha, which traveled to the Museum of Contemporary Art, Los Angeles, and then to the National Gallery of Art, Washington, DC. Also in 2004, the Museum of Contemporary Art in Sydney mounted a selection of the artist's photographs, paintings, books, and drawings that traveled to the Museo Nazionale delle Arti del XXI Secolo, Rome, and to the Scottish National Gallery of Modern Art, Edinburgh. In 2006, another exhibition of Ruscha's photographs was organized for the Jeu de Paume, in Paris. Ruscha represented the United States at the 51st Venice Biennale in 2005. In 2009, the Hayward Gallery, London, mounted a retrospective of the artist's paintings, *Ed Ruscha: Fifty Years of Painting*.

Glenn Adamson is Head of Research at the Victoria and Albert Museum, London, and a specialist on the history and theory of craft and design. He is coeditor of the triannual *Journal of Modern Craft*, the author of *Thinking Through Craft* (Berg Publishers/V&A Publications, 2007), *The Craft Reader* (Berg, 2010) and *Invention of Craft* (Berg, 2012). Adamson's other publications include the coedited volumes *Global Design History* (Routledge, 2011) and *Surface Tensions* (Manchester University Press, 2012). He has also curated numerous exhibitions, including *Postmodernism: Style and Subversion 1970 to 1990*, at the V&A.

Josh Luke began sign painting in 2005 as an apprentice at New Bohemia Signs in San Francisco. After working there for five years, he moved to Boston and started Best Dressed Signs with his wife, Meredith. He recently founded the Pre-Vinylite Society, a community of like-minded sign and lettering enthusiasts. Luke is invested in keeping the tradition of hand-painted signs alive, often mentoring young sign writers and conducting sign-painting demonstrations in the Boston area. Luke was interviewed for *Sign Painters*, the documentary and the book, in both San Francisco and Boston. He provided all the hand-brushed lettering in the pages of this book.
www.bestdressedsigns.com

Ira Coyne is a sign painter working under the moniker I. C. Signs. His career began in 1984 when he won a gallon of house paint at a school raffle. At nineteen, he experienced an epiphany that led him to become a sign painter under the influences of masters Phil Vandervaart and Vince Ryland. Coyne operates out of his home in Olympia, Washington. He enjoys tall trees, low clouds, and feathers. Coyne has provided guidance for the documentary *Sign Painters* and was interviewed for the film in Olympia in 2010. He also designed and painted the cover for this book.
www.iracoyne.com

Information about the *Sign Painters* documentary can be found online at www.signpaintermovie.com.

ACKNOWLEDGMENTS

First off, we must extend endless thanks to our editor, Sara Bader. Without her patience and commitment to this project, hours of our documentary footage would never have found their way into printed form. Many people have helped us make this book a reality, but without Jonah Mueller's organizational talents the last days before the deadline would have been grim. Thanks to Paul Wagner for his excellent design work, and to everyone at Princeton Architectural Press who worked closely with us to make this book possible.

We're eternally grateful to the talented individuals who had a direct hand in the creation of the book's content. To Ed Ruscha, Glenn Adamson, Ira Coyne, Josh Luke, and Travis Auclair, thank you so very much.

Thank you to the Center for Craft, Creativity, and Design. The 2011 Craft Research Fund grant awarded to Faythe Levine helped this project move forward and become a reality.

Additional thanks to: Maureen Post, Chris Thompson, Cole Quamme, Erica Bech, Susan Falls, Timm Gable, Tom McIltrot at *SignCraft* magazine, and Tod Swormstedt at the American Sign Museum.

Faythe would like to thank Aaron Polansky for his love and incredible amount of patience. Sam probably thanks him, too; otherwise Faythe would be difficult to work with. And without the continual overwhelming support of her parents, Rick Levine and Suzanne Wechsler, and her community, none of this would be possible.

Sam would like to thank his parents, John and Christine, as well as his sisters, Melissa and Hannah. He owes everything to their love and unwavering support. He would also like to thank his friends, without whom life would be impossible, not to mention boring.

IMAGE CREDITS

*All images courtesy of the authors except
for the following:*

Sean Barton: 30 (top), 32 (top), 33. Drink Coca-Cola
sign commissioned by Monroe Laundry Co.,
Seattle, WA, and painted with Jason Diaz, 2011.

Grant Beaugard: 69 (bottom), 70, 72–73. Nineveh
food truck, Olympia, WA, painted with Japhy
Witte based on a design by Julia-Anne Bork,
2011. Olympia Knitting Mills sign, Olympia, WA,
originally painted in the 1920s and repainted
in 2008.

Bob Behounek: 52–53, 54–55 (top)

Bob Bertell: 78–79

Butera School of Art, Boston, MA: 17

Jeff Canham: 109 (bottom), 110 (left), 111–13. Avian
establishments built by Luke Bartel and painted
by Jeff Canham.

John Downer: 97 (bottom), 98–101

Caitlyn Galloway: 87–89

Justin Green: 39 (bottom), 40–43

Scott Harrison: 104

Bruce Knecht: 128 (right, top and bottom), 129

Rick Levine: 106–7

Josh Luke: 122–25

Norma Jeanne Maloney: 58, 59 (left), 61 (top and
bottom left)

Gary Martin: 63 (bottom), 65–67

Mike Meyer: 14, 91 (bottom)

Mark and Rose Oatis: 46, 48–49

Stephen Powers: 36, 37 (top)

Ed Ruscha: 8

SignCraft Publishing Co., Inc.: 54 (bottom), 55
(bottom), 132 (bottom)

Sean Starr: 81 (bottom), 82

Damon Styer: 117–19

Roderick Laine Treece: 76–77

Phil Vandervaart: 141 (bottom), 142–143. The Rayvic
Co. lettering designed and painted by Phil
Vandervaart. Clockwork sign repaint designed
by Phil Vandervaart with assistance from Forrest
Wozniak. Dusty's Bar sign redesigned and painted
in 2011 by Phil Vandervaart with assistance
from Forrest Wozniak.

Wagner School of Sign Arts Publishers: 161–83

Forrest Wozniak: 147 (bottom left). Dibs Cafe sign,
Winona, MN, designed and painted by
Forrest Wozniak with assistance from Phil
Vandervaart, 2011.

Chas. L. H. Wagner's

BLUE PRINT
TEXT BOOK
OF
SIGN
and
SHOW CARD
LETTERING

WAGNER SCHOOL OF SIGN ARTS · PUBLISHERS · BOSTON · MASS.

Ode to Our Ancient Craft

By CHARLES L. H. WAGNER

BROTHERS in ancient crafts, our heritage
Is rich in art and all its best ideals;
 We boast of kinship with the world's renowned,
And trace our ancestry five thousand years,
Aye, more than that, for in antiquity
Remote from modern times and modern ways,
Our predecessors in Cathay's old streets
Were wont to mark the wares then sold in marts
And paint their dragons to attract the crowd.
Did not the early Pharaohs view with pride
The chiseled forms by forebears of our kind?
Have we forgot Belshazzar's lurid feast,
When mystic hands emblazoned mystic words
Illumined with a flash of holy light?

YEA, Constantine and Caesar followed paths
Marked out for them by craftsmen, skilled with reeds,
 The classic types of which we moderns boast.
Greeks made with cunning hand and carved with ease;
The mediaeval monks and writers' guilds
Preserved our art when lights of progress blurred
Until the Renaissance of golden age
When Tagliente and old Dürer wrought
To bring perfection to the letter craft.
Immortal Shakespeare must have owed some fame
To him whose pot and brush proclaimed his plays,
And pictured inns in days of good Queen Bess
Gave proof of talent worthy to endure
And shield its own from Envy's cruel darts.

YE bear the torch which ages past have lit,
Yours is the light that guides the doubter's feet;
 Men look to you to lead and show the way,
Will ye be false to all that's been bequeathed?
Have ye that holy zeal which braves the world
And dares to stand a bulwark for your rights?
Have ye no shame when men decry your trade
And by disparagement besmirch your toil?
Has vision fled or retrospective pride?
Is Yesterday's achievement all for naught?
Fools mourn today and fear tomorrow's goads.
Ye who have faith shall see the borning sun
Bless with a rainbow kiss our ancient craft.
Yea, Time shall bring due honor to our name.

PLATE 1

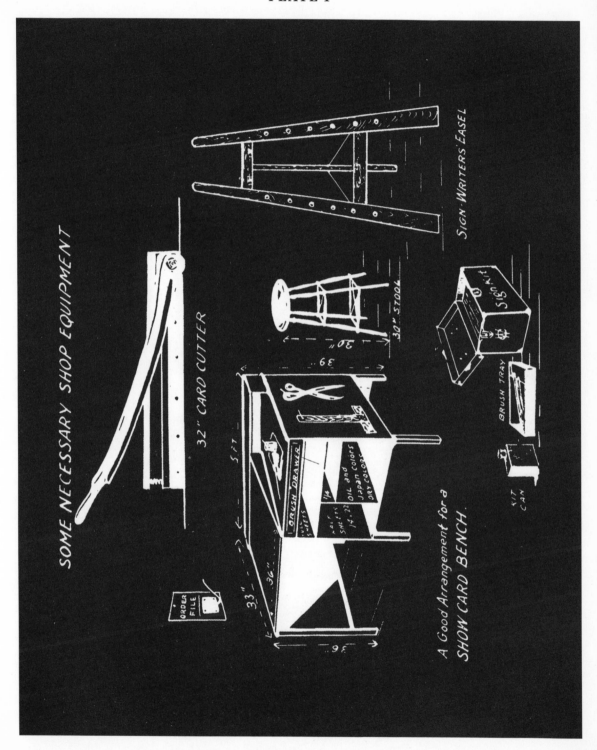

SOME NECESSARY SHOP EQUIPMENT

SIGN WRITER'S EASEL

32" CARD CUTTER

30" STOOL

SIGN KIT

BRUSH TRAY

KIT CAN

ORDER FILE

BRUSH DRAWER

FULL SHEETS

HALF SHEETS

1/4

14, 22 OIL and COLORS
Japan Colors
DRY COLORS

A Good Arrangement for a
SHOW CARD BENCH.

PLATE 2

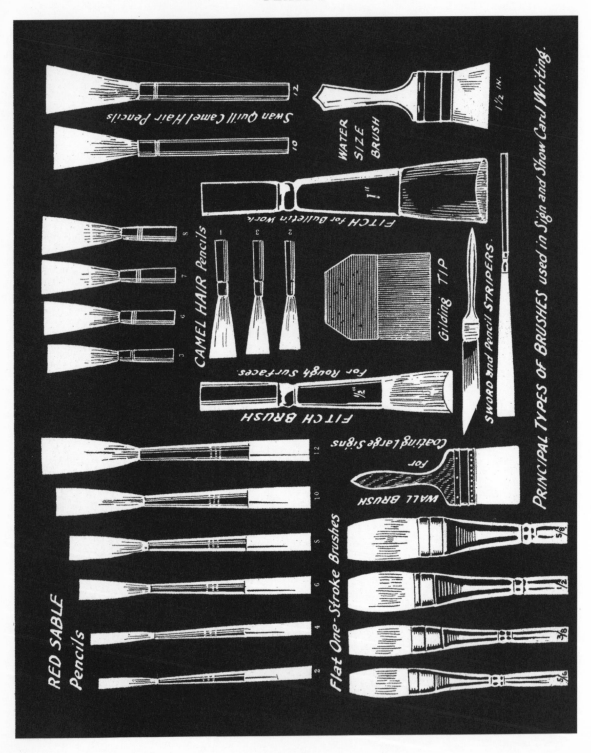

Swan Quill Camel Hair Pencils

WATER SIZE BRUSH

1/2 IN.

FITCH for Bulletin work.

1"

CAMEL HAIR Pencils

Gilding TIP

SWORD and PENCIL STRIPERS.

For Rough Surfaces.

FITCH BRUSH

1/2"

for Coating Large Signs

WALL BRUSH

RED SABLE Pencils

Flat One-Stroke Brushes

5/8

1/2

3/8

5/16

PRINCIPAL TYPES OF BRUSHES used in Sign and Show Card Writing.

PLATE 3

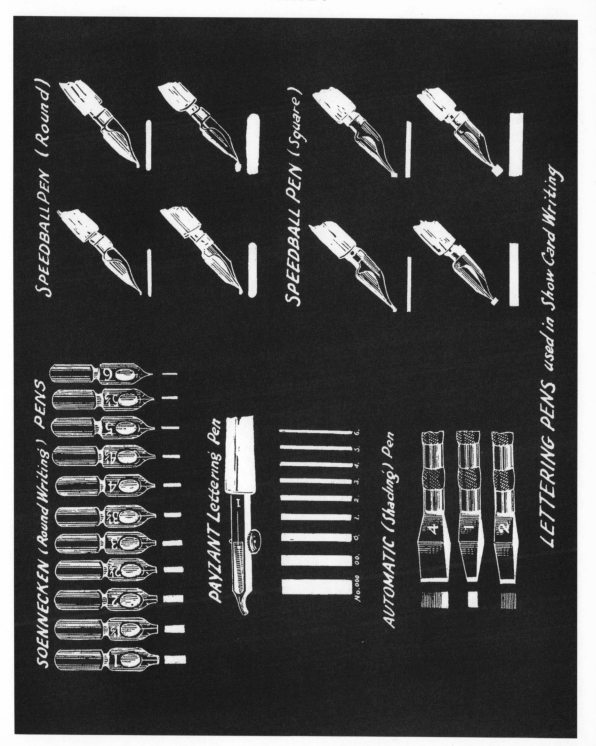

PLATE 4

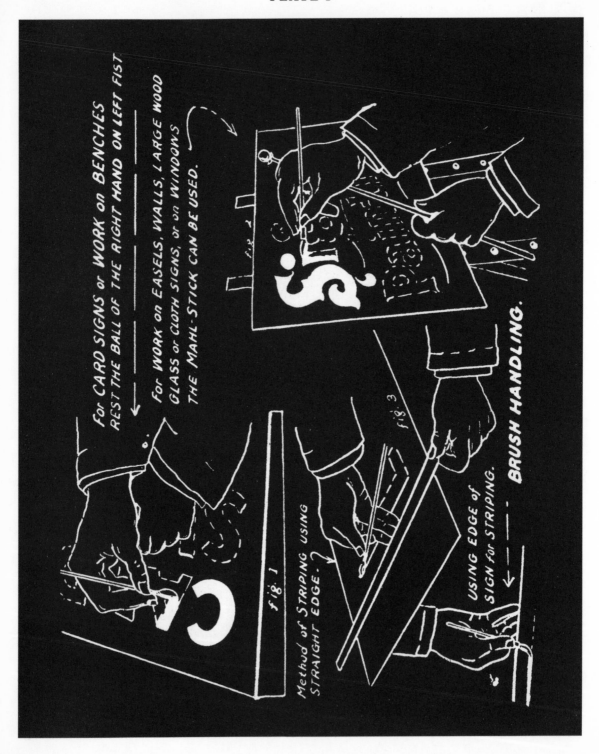

For CARD SIGNS or WORK on BENCHES
REST THE BALL OF THE RIGHT HAND ON LEFT FIST

For WORK on EASELS, WALLS, LARGE WOOD
GLASS or CLOTH SIGNS, or on WINDOWS
THE MAHL-STICK CAN BE USED.

fig. 1

Method of STRIPING USING
STRAIGHT EDGE.

fig. 3

USING EDGE of
SIGN for STRIPING.

BRUSH HANDLING.

PLATE 5

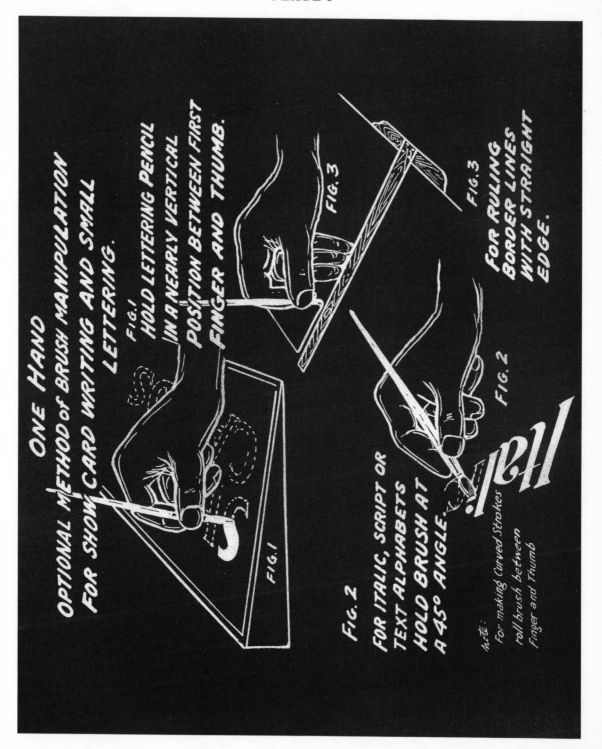

ONE HAND

OPTIONAL METHOD OF BRUSH MANIPULATION
FOR SHOW CARD WRITING AND SMALL
LETTERING.

FIG.1
HOLD LETTERING PENCIL
IN A NEARLY VERTICAL
POSITION BETWEEN FIRST
FINGER AND THUMB.

FIG.3
FOR RULING
BORDER LINES
WITH STRAIGHT
EDGE.

FIG. 2
FOR ITALIC, SCRIPT OR
TEXT ALPHABETS
HOLD BRUSH AT
A 45° ANGLE.

Note:
For making curved strokes
roll brush between
finger and thumb

FIG.1

FIG.3

FIG.2

PLATE 6

COMPARATIVE ELEMENTARY STROKES *of the* EGYPTIAN, ROMAN, SCRIPT, ITALIC *and* TEXT FOR CHISEL EDGE LETTERING BRUSHES or FLAT PENS.

EGYPTIAN - UNIFORM WEIGHT.

ROMAN THICK AND THIN ACCENTED STROKE HEAVY, UNACCENTED, LIGHT.

ITALIC AND SCRIPT Down Strokes Accented HAIR LINES on Up strokes and Horizontals.

OLD ENGLISH *and* TEXT ACCENTED AND UNACCENTED THE SAME AS THE ROMAN.

SPUR (ROUND SERIF)

L-SERIF

PLATE 7

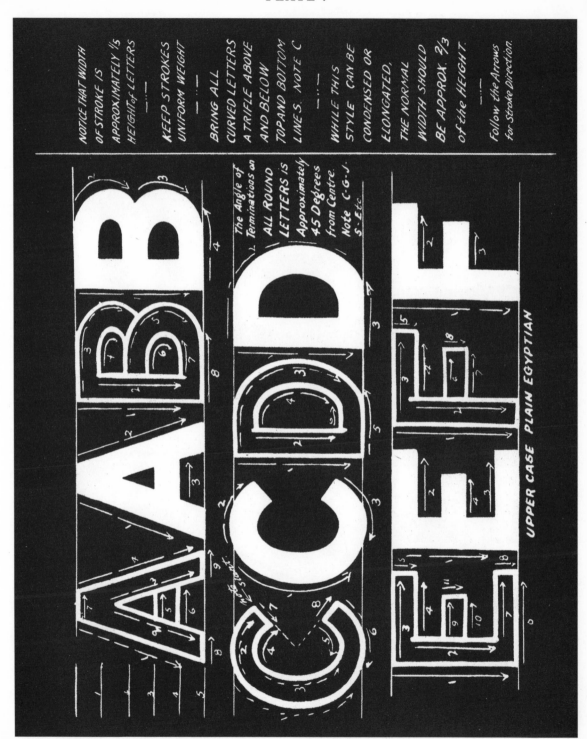

UPPER CASE PLAIN EGYPTIAN

PLATE 8

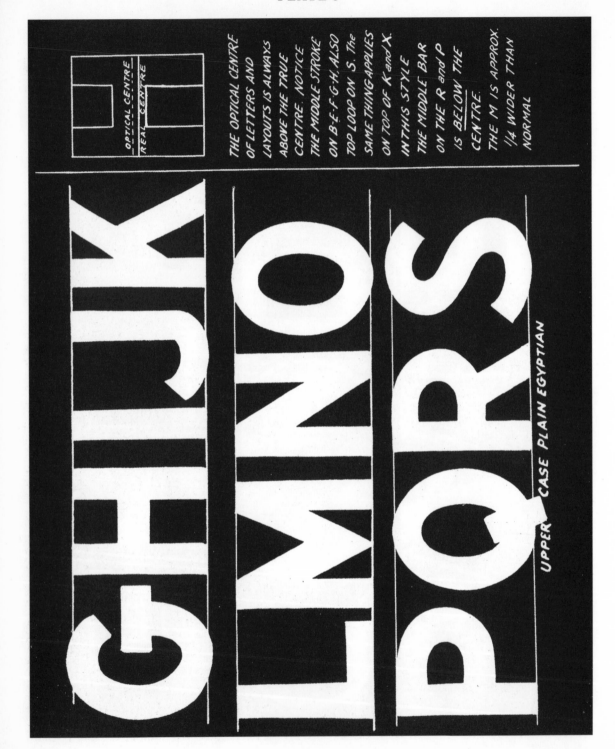

THE OPTICAL CENTRE OF LETTERS AND LAYOUTS IS ALWAYS ABOVE THE TRUE CENTRE. NOTICE THE MIDDLE STROKE ON B-E-F-G-H. ALSO TOP LOOP ON S. The SAME THING APPLIES ON TOP OF R and X. IN THIS STYLE THE MIDDLE BAR ON THE R and P IS BELOW THE CENTRE. THE M IS APPROX. ¼ WIDER THAN NORMAL

OPTICAL CENTRE
REAL CENTRE

GHIJK
LMNO
PQRS

UPPER CASE PLAIN EGYPTIAN

PLATE 9

NOTE THE COMPOUND CURVE ON THE FIGURE 2

THE TOP PART OF 3-5-6-8 IS SMALLER THAN BOTTOM 9 IS THE REVERSE

THE ANGLE OF TERMINATIONS ON 2-3-4-5-6-9 IS 45° ALL SHOULD CORRES-POND.

¢ and $ MARKS SHOULD NOT BE MADE MORE THAN ½ SIZE OF FIGURES.

1 2 3 4 5

6 7 8 9 0

¢ $

While these are the correct figures for the Egyptian Type, the Roman are more extensively used in Sign Writing, and are sometimes used in conjunction with Egyptian Letters.

PLAIN EGYPTIAN FIGURES

PLATE 10

REMEMBER THAT ALL THE ANGULAR TERMINATIONS ARE SLANTED APPROX 45° FROM CENTRE

THE LOWER CASE t IS CROSSED ON THE LINE, NOT ABOVE.

P-Q-Y LIKE G and J EXTEND 1/3 BELOW BASE LINE OF THE OTHER LETTERS

TOP AND BOTTOM ANGLES ON C-S SHOULD CORRESPOND.

mnopqr
stuvwx
yz &

LOWER CASE EGYPTIAN

PLATE 11

The Angle of Terminations on Shades is approx 45°

ALL Shaded Letters must correspond in this respect

The most common Shade is the 'Relief' Fig 1·2·3·4·5

All Shades on Light Grounds look Best in Tints.

ABCDE

RELIEF or 'OFF' SHADE (LEFT)

RELIEF OR 'OFF' SHADE (RIGHT)

FGHIJ

'DROP' SHADE (LEFT)

'CAST' SHADE (LEFT)

'DROP' SHADE (RIGHT)

KLMPO

'CONVEX'

'BLOCK' SHADE

'SPLIT' SHADE

SHADING.

'BLENDED' SHADE

PLATE 12

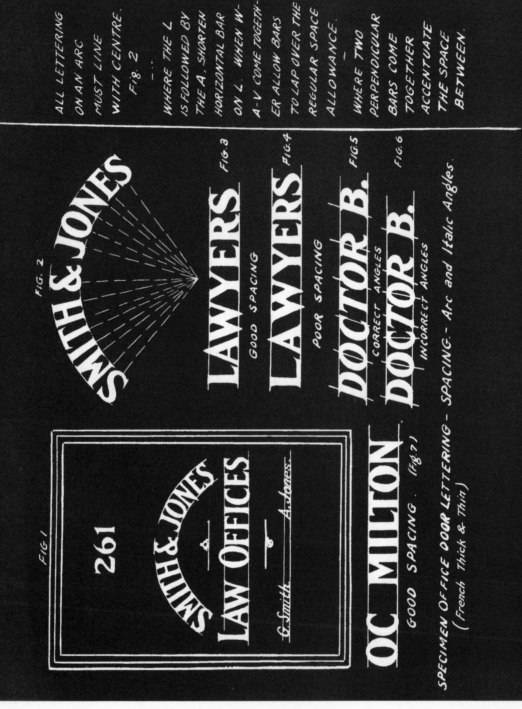

ALL LETTERING
ON AN ARC
MUST LINE
WITH CENTRE.
Fig. 2

WHERE THE L
IS FOLLOWED BY
THE A. SHORTEN
HORIZONTAL BAR
ON L. WHEN W-
A-V COME TOGETH-
ER ALLOW BARS
TO LAP OVER THE
REGULAR SPACE
ALLOWANCE.

WHERE TWO
PERPENDICULAR
BARS COME
TOGETHER
ACCENTUATE
THE SPACE
BETWEEN.

FIG. 1

FIG. 2

SMITH & JONES

261

SMITH & JONES
LAW OFFICES
G. Smith. A. Jones.

OC MILTON (Fig. 7)
GOOD SPACING.

LAWYERS FIG. 3
GOOD SPACING

LAWYERS FIG. 4
POOR SPACING

DOCTOR B. FIG. 5
CORRECT ANGLES

DOCTOR B. FIG. 6
INCORRECT ANGLES

SPECIMEN OFFICE DOOR LETTERING - SPACING: - Arc and Italic Angles.
(French Thick & Thin)

PLATE 13

REMEMBER -
In laying out
Signs, poor
spacing will
spoil the effect
of the finest
lettering.

All work must
have plenty of
margin space
to be most
effective.

Perfect Balance
is necessary on
all layouts.

Illustrations
and scrolls if
not overdone,
relieve the
monotony of
lettering.

Poor Arrangement.

BOOKS
for
VACATION
READING

FICTION, POETRY,
HISTORY, TRAVEL,
GEOGRAPHY, ETC.

Old Corner Book Store.

Fig 2

ITALIC
A
FIG. 7
OPTICAL CENTRE
REAL CENTRE
Fig 1

X
FIG 8

MECHANICAL LAYOUT
SIGNS

ARTISTIC LAYOUT
ART SHOW CARD
Fig. 6

Fig. 5

Good Arrangement.

BOOKS
✧ FOR ✧
VACATION
READING

FICTION, POETRY,
HISTORY, TRAVEL,
GEOGRAPHY, Etc.

Old Corner Book Store.

IMPERFECT BALANCE

PERFECT BALANCE

Fig. 3
Fig. 4 →

SIGN LAYOUTS AND BALANCE.

PLATE 14

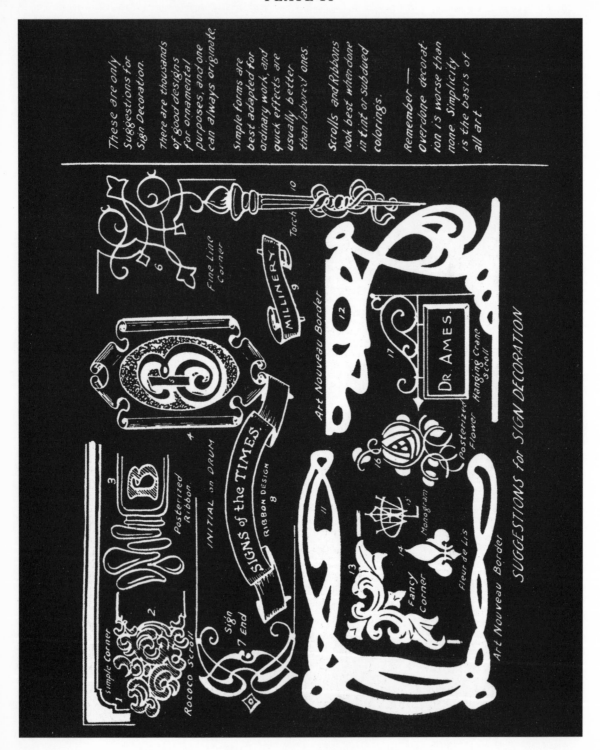

These are only
Suggestions for
Sign Decoration.

There are thousands
of good designs
for ornamental
purposes, and one
can always originate.

Simple forms are
best adapted for
ordinary work, and
quick effects are
usually better
than labored ones.

Scrolls and Ribbons
look best when done
in tint or subdued
colorings.

Remember —
overdone decorat-
ion is worse than
none. Simplicity
is the basis of
all art.

SUGGESTIONS for SIGN DECORATION

PLATE 15

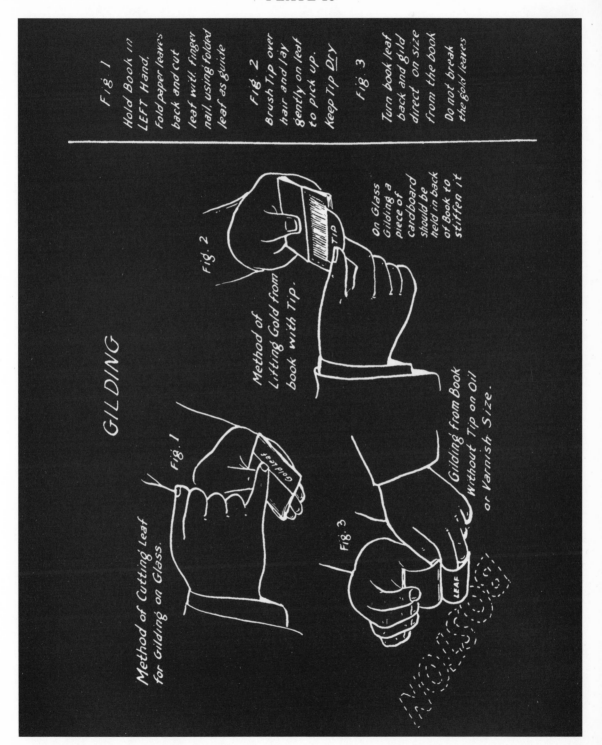

Fig 1
Hold Book in LEFT Hand.
Fold paper leaves back and cut leaf with finger nail, using folded leaf as guide

Fig 2
Brush Tip over hair and lay gently on leaf to pick up.
Keep Tip _Dry_

Fig. 3
Turn book leaf back and gild direct on size from the book
Do not break the gold leaves

GILDING

Method of Cutting Leaf for Gilding on Glass.

Method of Lifting Gold from book with Tip.

On Glass Gilding a piece of cardboard should be held in back of book to stiffen it

Gilding from Book without Tip on Oil or Varnish Size.

Fig. 1

Fig. 2

Fig. 3

PLATE 16

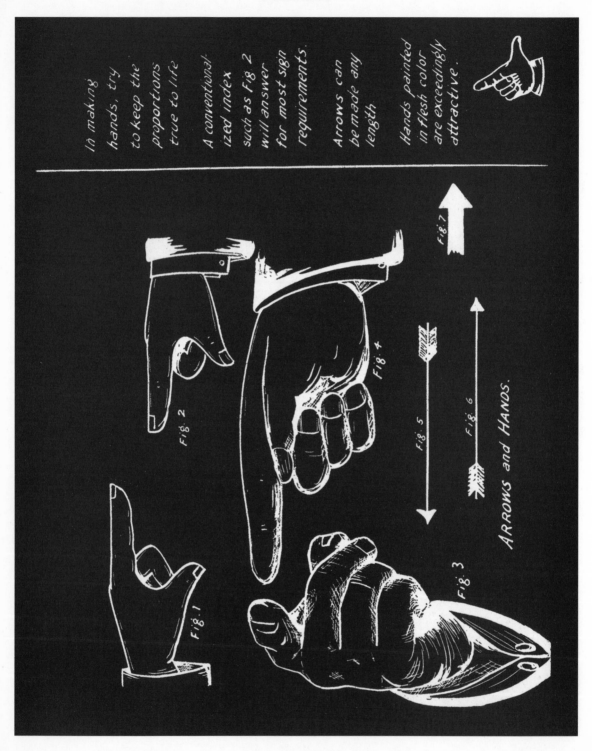

In making hands, try to keep the proportions true to life.

A conventionalized index such as Fig 2 will answer for most sign requirements.

Arrows can be made any length

Hands painted in flesh color are exceedingly attractive.

Fig. 7

Fig. 2

Fig. 4

Fig. 5

Fig. 6

Fig. 1

Fig. 3

ARROWS and HANDS.

PLATE 17

ENLARGING by SCALE and MAKING AN ELLIPSE.

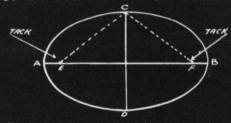

FOR MAYOR

METHOD USED BY THE TRADE FOR ENLARGING PICTURES, TRADE MARKS, DESIGNS. Etc., on WALLS, BULLETINS and SIGNS OF ALL KINDS. Scale must be accurately drawn otherwise distortion occurs.

TO MAKE AN ELLIPSE DRAW PERPENDICULAR and HORIZONTAL LINES THE SIZE OF ELLIPSE DESIRED. (A to B - C to D) MARK ON A RULE THE DISTANCE FROM A to CENTRE. HOLD ONE END OF THIS ON POINT C, AND WHERE THE OTHER TOUCHES THE HORIZONTAL LINE INSERT A TACK. (E) REPEAT ON RIGHT SIDE, (C to F) ALSO INSERT A TACK ON POINT C. THEN FASTEN A PIECE OF TWINE TAUTLY AROUND TACKS. REMOVE TACK AT POINT C AND DRAW ELLIPSE BY FORCING PENCIL POINT AGAINST THE TWINE TACKS AT L and F DETERMINE LENGTH AND AT C THE WIDTH.

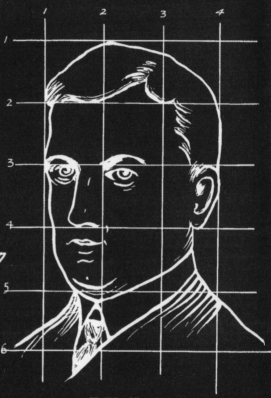

FOR MAYOR

PLATE 18

SPECIMEN SIGN SKETCHES - New York Roman

LEAVE PLENTY
OF MARGIN
AND SPACE
BETWEEN
LETTERS.

BE SURE TO
CENTRE
ALL LINES
OF COPY.

FOR BELT
SIGNS TO
BE ERECTED
ON BUILDINGS
AND OF A
PERMANENT
NATURE. THE
N.Y. ROMAN
IS UNEXCELLED.

FLAT or RAISED
GOLD LETTERS
IN THIS STYLE
ARE ALWAYS
ACCEPTABLE
TO MERCHANTS.

DRUGS

HEAVY FACED

SODA

LIGHT FACED

Confectionery

LOWER CASE

PLATE 19

A FEW WELL KNOWN TRADE MARKS SEEN ON SIGNS

WHEN TRADE MARKS ARE TO BE REPRODUCED, THEY SHOULD BE COPIED WITH ABSOLUTE FIDELITY TO THE ORIGINAL COPY, BOTH IN COLOR AND DESIGN.

Wagner School

PLATE 20

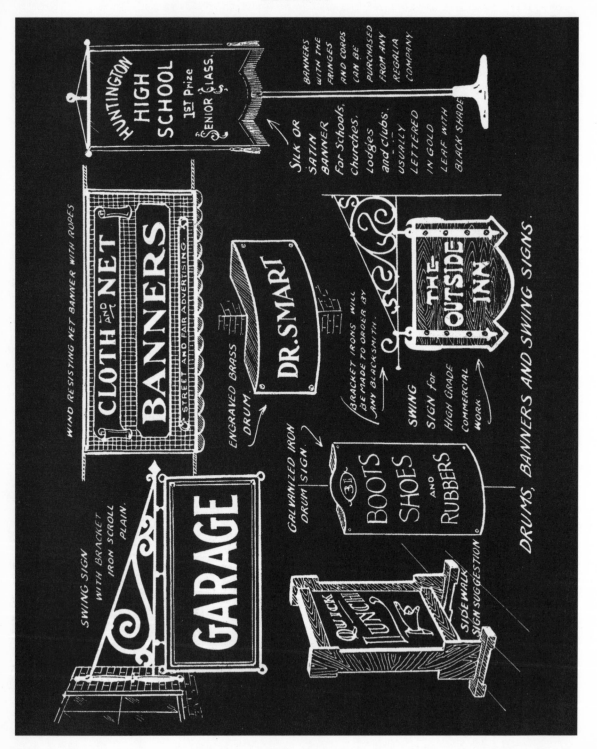

PLATE 21

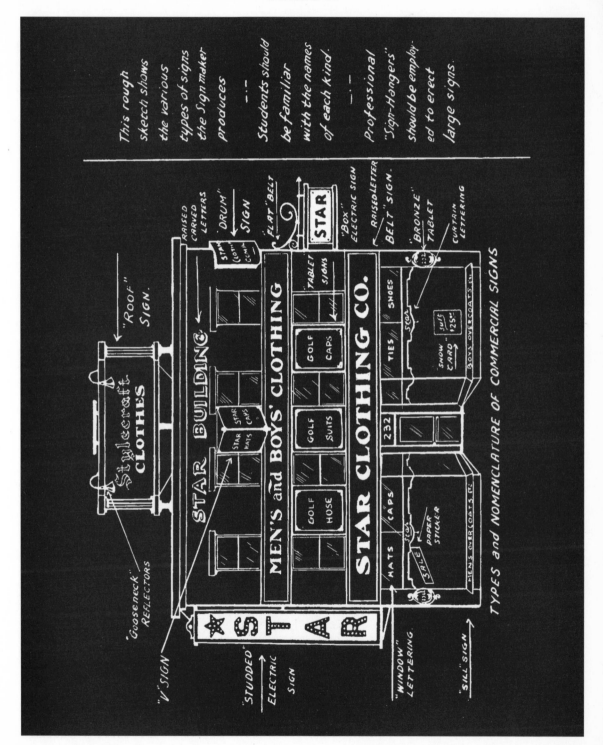

This rough sketch shows the various types of signs the Signmaker produces

— :: —

Students should be familiar with the names of each kind.

— :: —

Professional "Sign-Hangers" should be employed to erect large signs.

TYPES and NOMENCLATURE OF COMMERCIAL SIGNS

The diversity of the backgrounds of signpainters make
them impossible to type, as has been done with
many professions. He wears no uniform, nor does he have
any distinguishing characteristics that set him
apart from other men, in spite of the fact that Hollywood has
tried from time to time to put him in white overalls.
Having neither diploma nor college degree to lean on, he must
prove his qualifications by his ability alone.
This ability is displayed all over town and he is always glad
to furnish prospective customers with the address
of the location of some of his handiwork, an advantage not
shared by most professional men.
—**Syl Ehr**
*Signpainters Don't Read Signs: Memories of and
Reflections on an Ancient Art* (1957)